CW00797716

READ ME

Read Me: Selected Works
Copyright © Holly Melgard, 2023

ISBN 978-1-946604-04-0
First Edition, First Printing, 2023

Ugly Duckling Presse
The Old American Can Factory
232 Third Street #E-303
Brooklyn, NY 11215
uglyducklingpresse.org

Distributed in the USA by SPD/Small Press Distribution
Distributed in the UK by Inpress Books

Cover design by IngeInge
Design and typesetting by dourmoose
The type is Helvetica and Georgia

Photographs of *Money* and *Reimbur$ement* are from the Library
of Artistic Print on Demand <apod.li>.

Printed and bound at Sheridan (Saline, MI)
Covers printed letterpress at Ugly Duckling Presse

The publication of this book was made possible, in part, by public
funds from the New York City Department of Cultural Affairs
in partnership with the City Council, and by the New York State
Council on the Arts with the support of the Office of the Governor
and the New York State Legislature.

READ ME

SELECTED
WORKS

HOLLY MELGARD

CONTENTS

SHAPES FOR BABY 211

TALKING 249

NOTES 299

ACKNOWLEDGMENTS 307

SOUNDING

INTRODUCTION

—for eight "voice" recorders

Is this thing on?

Testing. Testing.

One two three.

Can everyone hear me?

All the way in the back?

No?

How's that, turn it up more?

Turn it up a little more than that.

That's good.

No, now that's too loud.

Just a hair less.

Can everyone hear me now?

Is there an ECHO Echo echo...

This is a test.

This is a test of a test.

I'm testing you.

I promise I'm testing you.

I mean I promise I *will* test you.

I promise I will promise.

I mean, I promise *to* promise.

Promise me you'll promise me too.

I mean, promise me you'll promise not to threaten.

Promise you won't threaten to promise, but that you'll actually threaten to threaten.

Don't threaten me; I'm threatening you!

Are you threatening me?

Or are you threatening to threaten me?

I'm so on the verge of threatening to promise you here.

Threaten to promise me too.

Are you listening to me? I'm listening to you.

Ok, I threaten to promise you too.

Are you listening to me listen to you? I'm listening to you threatening me.

I mean, I'm listening to you threatening to listen to me.

Promise me you'll listen to me threatening you.

I promise to listen to you if you promise to listen to me too.

At least I promised to listen to you.

You couldn't even promise to listen to me listening to you.

Listen to me listening to you threatening me.

I sound like I'm promising you.

But you can't even promise to listen to me listening to you threaten me.

I promise I'll threaten you if you promise not to threaten me.

But I'm not going to threaten to promise you so long as you're not listening to me.

I listen to you when you listen to me.

Why don't you listen to me listening to you threaten me?

Why don't you listen to me listening to you promise me?

And why am I always the one promising to threaten when you can't even so much as promise to promise the same?

I made that threat. You made that promise.

You promised that you'd promise.

You promised that you would promise to listen.

And I listened to you promise to threaten.

I'm still listening to you promise to threaten.

Why can't you ever threaten to just threaten, instead of all of these promises, under threat.

Promise, promise, promise! That's all you ever threaten to do.

And that's all I ever listen to.

So why can't you ever listen to a single promise?

I mean, why would anyone promise to listen to promises when you won't even promise to listen in the first place?

NARSOLICITATION

—for loop pedal

Retrospective To-Do #232: All the great philosophers walked because circulation in the legs I guess has something to do with memory.

Retrospective To-Do #233: Balzac died of a caffeine overdose with 55 shots of espresso in his system. Balzac didn't take intentional walks.

Retrospective To-Do #234: Intentional is never intentional because "tend" shares an affinity with the word "tense," which is both retro and proactively synonymous.

Retrospective To-Do #231: Walking is was always never a synonym for wandering wanting waiting so saying sending sent said.

Sending is a synonym for saying
Saying is a synonym for signing
Signing is a synonym for library
Libraries are synonyms for lying
Lying is a synonym for living
Living is a synonym for lazing
Lazing is a synonym for loosing
Loosing is a synonym for snoozing
Snoozing is a synonym for synapse
Synapse is a synonym for saming
Saming is a synonym for shaming
Shaming is a synonym for sharing
Sharing is a synonym for social
Social is a synonym for crucial
But crucial is a synonym for pushover
Pushover is a synonym for shower
Shower is a synonym for flurries
Flurries are synonyms for floundering
Floundering is a synonym for filling
and filling is just a synonym for filing
if filing is a synonym for finding
and finding is a synonym for fondling
then fondling must be a synonym for fucking
and fucking is a synonym that is fucking jarring
so then jarring is a synonym for pickling
in which case pickling here should stand as a synonym
for pending

I'm currently researching the culture of me populating the network at large.

I've "friended" every person on Facebook whose name sounds like mine.

Hypothetically, if the name Holly Melgard were shouted in a noisy room, those who inhabit the same sound in language would belong.

Here are some excerpts from my inbox.

Holly Milgard confirmed you as a friend on Facebook
Wally Melgard confirmed you as a friend on Facebook
Polly Melgard confirmed you as a friend on Facebook
Molly Melgard confirmed you as a friend on Facebook
Milly Melgard confirmed you as a friend on Facebook
Polly Milgard confirmed you as a friend on Facebook.
Molly Milgard confirmed you as a friend on Facebook.
Milly Milgard confirmed you as a friend on Facebook.
Molly Helgard confirmed you as a friend on Facebook
Heidi Melgard confirmed you as a friend on Facebook
Heidi Miligard sent you a message on Facebook:

I'm sorry but do we know each other?

holl://melgard.com/DoYouKnowMeOrSomething/
NoIdon't/CantYouRead/NoClearlyIcan't/NeitherCanI/

Retrospective To Do #423.687: Slurp up the sea in its entirety.

Retrospective To Do #423.681: Extract emotionally dyslexic samples from the space-and-time pile.

Retrospective To Do #423.68: Rotate in megaphors periodically.

Retrospective To Do #423.679: Modify further clauses in the modification pile.

Retrospective To Do #423.678: Reorganize the You's and I's as sideways in the influx of either.

Holly Hilgard confirmed you as a friend on Facebook
Molly Hilgard confirmed you as a friend on Facebook.
Hilla Hilgard confirmed you as a friend on Facebook.
Polly Hilgard confirmed you as a friend on Facebook.
Hilla Melgard confirmed you as a friend on Facebook.
Polly Milgard confirmed you as a friend on Facebook.
Holly Mailgard confirmed you as a friend on Facebook.
Hilla Mailgard confirmed you as a friend on Facebook.
Polly Mailgard confirmed you as a friend on Facebook.
Holly Molgard sent you a message on Facebook:
> *And you are?*
Molly Mollard sent you a message on Facebook:
> *Am I supposed to know who you are?*

holl://melgard.com/conductive/constructive/con-
stancy/conservative/conservation/conversation/
constellation/consolation

Retrospective To-Do #613: Mistakenly say the word "conductor," and then spend the next 6 years deciphering it.

Retrospective To-Do #423.683: Calculate the geometry of interrelations and de-calculate the metrics of outer-relations at the same time.

Retrospective To-Do #423.676: File them under the inconsequential strokes of our social calligraphy.

Retrospective To-Do #423.672: Pickle them in the waters of the unreality-bog.

Retrospective To-Do #423.671: Express hostility toward the furthest bounding boxes of virtual and actual shapes.

Hilla Mulgard confirmed you as a friend on Facebook.
Polly Mulgard confirmed you as a friend on Facebook.
Holly Mulgard confirmed you as a friend on Facebook.
Hilla Milegard confirmed you as a friend on Facebook.
Polly Milegard confirmed you as a friend on Facebook.
Holly Milegard confirmed you as a friend on Facebook.
Molly Milegard sent you a message on Facebook:

Do you know me or something?

holl://melgard.com/friends/agorophopia/
metaphoraphobia/moraphobia/gloraphobia

Retrospective To-Do #423.67: Exacerbate the will-do, what-now, and the you-know fonts and filters.

Holly Melgrad confirmed you as a friend on Facebook

Molly Melgrad confirmed you as a friend on Facebook.

Molly Bolgard sent you a message on Facebook:

> *I don't friend strangers.*

Hilla Melgaard confirmed you as a friend on Facebook

Helga Melgaard sent you a message on Facebook:

> *hvem er du og hvor er du fra*

Melly Hildagard confirmed you as a friend on Facebook.

Molly Heldagard confirmed you as a friend on Facebook.

Milly Heldegard posted a link on your wall:

> *"I lost 15 pounds in under two weeks and so can you!"*

Milly Heldegard posted a link on your wall:

> *"Invest in your future by investing in today. Free stock advice from the experts."*

Milly Heldegard invited you to join the group:

> *"Secret shopper service saves hundreds of dollars for little to no work at all!"*

Milly Heldegard sent you a message on Facebook.

Milly Heldegard sent you a message on Facebook.

Milly Heldegard sent you a message on Facebook.

Milly Heldegard sent you a message on Facebook.

Milly Heldegard sent you a message on Facebook.

Milly Heldegard sent you a message on Facebook.

holl://melgard.com/cult/friends/followers/family/
strangers/traitors?/spies

Retrospective To-Do #179: McCarthy wrote a list that included the letters I, O, and U. Why?

Retrospective To-Do #39: The conspiracy of my mother.

Retrospective To-Do #40: The conspiracy of your mother.

Retrospective To-Do #41: The conspiracy of yours.

Retrospective To-Do #42: The conspiracy of you's.

Milly Heldegard sent you a message on Facebook.
Milly Heldegard sent you a message on Facebook.
Milly Heldegard sent you a message on Facebook.
Milly Heldegard sent you a message on Facebook.
Milly Heldegard sent you a message on Facebook.
Milly Heldegard sent you a message on Facebook.
Milly Heldegard has compared you to another friend on Facebook.
Milly Holgard sent you a message on Facebook:
I don't know you, but I think I get the joke?

holl://melgard.com/agendas/ToDo's/friendships/
defriendships/populus/megalopolis/apolis

Retrospective To-Do #423.686: Implement a physical-body pile.

Retrospective To-Do #909: Remember those division tables and not just those multiplication tables at the same time.

Retrospective To-Do #920: Maximalism is the new minimalism.

I invited 37 permutations of Holly Melgard to be my friend. In the culture of me, 61% of us have publically legitimized our friendship, all of whose names sound closest (Molly's, Holly's, Polly's, Millards, and Milgards alike). 12% sent me messages inquiring how I knew them, all of whom had O's in their name (2 Molgards, one Bolgard, one Nelly Nolgard, plus some extra syllable names who politely declined my request directly through email). 8% of us include smoking cigarettes in our interests category. 45% of us include pictures of our cats under pictures of ourselves. 37% of us update our status at least once every other day. 21% of us update our status every day, and 18% of us update our status less than once a week. Two of us are linguists. 7 of us are musicians. 6 of us publicly admit that we like to sing.

holl://melgard.com/music/artifice/rooms/yards/plots/
piles/holes/seeds/weeds

Retrospective To-Do #908: Then defer to "Tesla" and forget to correct it to the word "tender."

Retrospective To-Do #929: MineStein.

Retrospective To-Do #930: To be Frank *and* Stein.

Retrospective To-Do #931: Mîse-en-Stein

Heidi Nolgard is not my friend
Sally Nulgard is not my friend
Polly Pelgard is not my friend
Nelly Hillard is not my friend
Molly Hollard does not belong
Heidi Nilgard is not my friend
Sally Nilgard is not my friend
Polly Pilgard is not my friend
Nelly Hallard does not belong
Heidi Nulgard is not my friend
Sully Nulgard is not my friend
Polly Pulgard does not belong
Nelly Huellard is not my friend
Heidi Nailgard is not my friend
Sally Nailgard is not my friend
Polly Pailgard is not my friend
Nelly Hallard does not belong
Heidi Nowgard is not my friend
Sally Nowgard does not belong
Polly Powgard is not my friend
Nelly Howard does not belong

holl://melgard.com/sign/say/send/sent/said

Retrospective To-Do #543: The meteorological out-doors remain, and in an accident, child-safety locks can be deadly.

Retrospective To-Do #542: Spray the clouds with bullets to make it rain.

Retrospective To-Do #541: I asked my dad 'What if time weren't a spiral but a watershed?' and he said that was silly because time is really a bullet.

Retrospective To-Do #540: Bullets exfoliate the clouds exfoliate the rains exfoliate the pollution exfoliates the plumes.

Retrospective To-Do #267: Read the braille in the carpet.

So if saming is a synonym for laming
And laming is a synonym for luring
And luring is a synonym for landing
And landing is a synonym for slandering
Then slandering is a synonym for pandering
And pandering is a synonym for scaffolding
And scaffolding is a synonym for grappling
And grappling is a synonym for snickering
And snickering is a synonym for doodling
Then doodling is a synonym for pluming
So pluming is a synonym for tethering
And tethering is a synonym for smothering
And smothering is a synonym for smoldering
And smoldering is a synonym for smoking
Then smoking too is subject to gas
If gas is a synonym for gap
And gap is a synonym for crap
And crap is a synonym for sap
And sap is a synonym for syrup
Then syrup here must be a synonym for pavement

STAY

—for loop pedal

Ok, stop. Stay... Stay... Stayyyy—Stay. Stay. Stay! STAY! *Stay.* Stay—STAY. Come on, stay. Stay? Come on, stay there. Stay like that. Stay. Shh. Sh sh sh. Stay like that.

Ok, stop. Wait for it. Wait. Wait. Wait—wait. Wait! *Wait.* Wait? Wait for it, wait for it. Come on, *wait there.* Wait right there. Wait—Shhhh. Shh sh sh sh. Be quiet.

Ok, freeze! Hold it. Hold it. Hold it. Hold. Hold it. Hold it like that. Hold it just like that. Hold. Hold. Hold. *Hold it.* Hold it? Come on, hold it. Shhh. Sh sh sh sh.

Ok, stop freeze! Hold it, hold it, hold it. Hold it right there. Hold it. Holddd it. *Hold it.* Holddd. Hold? Come on, hold it there. Hold it right there. Shhhhh. Sh sh sh sh.

Ok, hold it. Freeze right there. Hold it. Hold on, hold on, hold on, hang on. Hold it right there, hold it there. Hold hold hold hold almost—Keep holding. Hold it like that. Just *hold it.* Shhh. Sh sh sh sh.

Ok, hold it right there. Freeze! Don't move. Don't moooove. Don't. Move. *Don't move.* Don't move! No moving. Don't don't don't don't don't move. Don't move. Don't. Don't! *Don't!* Just stop! Stop! Shhh. Shh. Shhh.

Ok, stop right there. Hold it. No, freeze! Just like that. Like that. Yeah, just like that. Right there. No no, like

that. No—Yeah, like that. Right there. No—There. No no no no no no no. No! Like that, yeah just like that. No, stop. Shh sh sh sh sh sh sh.

Ok, hold on, not yet. Hold please. Hold. Hold—No, freeze and hold it. Keep holding, keep holding. Not yet. Not yet. *Not yet.* I said not yet! Hold just like that. Hold it there. A little longer. Thank you for holding. Please continue to hold. Shhh sh sh sh sh.

Ok, hang on, not yet. Just hang on. No no don't—just freeze! Stay frozen. Hang on hang on hang on. Hang in there. Just a little... No no no no no don't! I said don't! Don't. Don't. *Don't.* Just wait! No, don't! Don't! *Don't!* No, no don't! Shhhh. Sh sh sh sh sh. Shhh!

Ok, hold it just like that. No, like that. Yeah, that. No, no, just freeze! And, hold it, hold it, hold it. Hold it please. Hold *on.* Please! *Please? PLEASE?!* Please be still. Stay like that. Yeah, just like that. No, not like that, no—yes—no. No! No no, hold. Hold! Shh! *Hold it!*

Ok, can you stop breathing? Seriously, stop breathing, and just freeze. You move when you breathe, so stop breathing. Just hold it in. No, hold it in. And hold a little longer—hold it, hold it. Hold it?! Keep holding. Whatever you do, don't breathe. *Don't breathe.* No no no no no no don't! Sh sh sh sh sh sh sh. It's ok.

Ok, so then hold it. Don't move. You're moving, when I specifically asked you not to move. Be perfectly still! Be still. Be still! Shh. Please oh please be still. Don't

move! I said *don't move*. Just be still, and don't—no no. Don't move don't don't. No no no don't don't don't! Just, Shhhh!

Ok, just wait. Hang on, not yet. Just wait. Hang on hang on hang on, just hang on. Just freeze. Hang in there. Hang on. I got this, just wait. Just you wait. Wait for it wait for it, hang on hang on hang on. No, wait. No. Wait for it! Woah woah woah wait wait wait. No no. Just wait—*Wait!* Shhh!

Ok, no. You're breathing, just stop breathing. Be still. No, no. Shhh! Sh sh sh sh sh. Be quiet. Just, Shh! Shhhhh! No, be silent, don't breathe, just be quiet. Quiet. Quiet. Quiet! *Quiet!* Quit it! Just freeze! Quit it! Quit it—quit it. *Quit it*. Quiiiiiiiiiit. Be quiet! No, quit quit it quit it quit it quit quit it. Quit it!!! Shhhhhh! *Shhhhhh! Shhhhhh!!!*

COLORS
FOR BABY

white

clear

cream

milk

glue

water

steam

fog

wind

sugar cube

salt

ash

rain

club soda

clean

tooth

smoke

screen

air

area

space

light

tissue

window

snow

sweat

mucus

moon

plaster

mayonnaise

plastic wrap

powder

paper

glass

cotton

ice cube

BOOKING

FROM THE MAKING OF THE AMERICANS

Introduction

NOW 'there is no such thing as repetition' in The Making of Americans, *because I deleted it. Herein, every word and punctuation mark is retained according to its first (and hence last) appearance in Gertrude Stein's 925-page edition of the book.*

First 100 words
(*The Making of Americans*, p. 3):

Once an angry man dragged his father along the ground through own orchard. "Stop!" cried groaning old at last, I did not drag my beyond this tree

It is hard living down tempers we are born with all begin well for in our youth there nothing more intolerant of than sins writ large others and fight them fiercely ourselves; but grow see that these really harmless ones to nay they give a charm any character so struggle dies away

has always seemed me rare privilege being American real one whose tradition taken scarcely sixty years create need only realise parents

<u>Middle 100 words</u>
(*The Making of Americans*, p. 129-163):

oblige minutes finish hand game contact hired fruit-
trees haymaking seed-sewing someway personal
jingling pockets scheming mixtures hay-making
cutting bread vegetables picking milking butter
cheese seasons ploughing bales storing Indians
darkness shouted crouched helped sowing seed mud
snow employed Madeleine Wyman superior Wymans
outburst burst latest biggest quantity bottom weaker
blown pushes breaks letting blustering settles stays
repeats bland neighbor pleasantly prompt paying
conditions watches sooner Jiving dangerous remains
swelled broken ingratiating diplomatic onward
cushion padding impulse mixes cooked dish flavor sink
wallow wallowing melting passes dissipation affect
splitting grimy dirt die escape float evil destroy despair
destroyed someone timid larger

flush feverish stepping laying respectfully addressing impressed re gift emptier ore correctly exasperating thankful disregarding profiting irregular scissors sharpening sharpened knife scissor preferring sharpen some-time humble reels eloquent adequate spirituality transcending solving intelligible enjoyable intensified demonstrating origin noisily drearily joyously boisterously despondingly fragmentarily roughly energetically repeatedly funnily hesitatingly dreamily doubtingly tilling boastingly delightfully touchingly quaintly flatly transparent trunk tenderly uninteresting daintily ruined jumping landing distance desolating jumped jump frighten exchanging explanations astonishes doubtful quarrelsome talkative breathless thank toss tossed rhythm regularity struck fully minding uninterested contradicting smelled gloominess noise noises disgust displease unlike buried everyday expository recognising regretted similar similarly

For The Making of the Americans, *Holly Melgard takes Gertrude Stein's credo "there is no such thing as repetition" literally and applies it to her highly repetitious and hard to read tome* The Making of Americans: Being a History of a Family's Progress *from 1925. Thus, "every word and punctuation mark is retained according to its first (and hence last) appearance in Gertrude Stein's 925-page edition of the book," deleting any other instance of repetition. This reading confronts Stein's procedural text with the assumptions of digital word processing, shrinking it to merely 21 pages of 'unique' content that evolves from readable sentences to a list of words. Melgard also adds page-spans of the original on each page to show how many pages are covered by its words.*

—*Annette Gilbert & Andreas Bülhoff*
Library of Artistic Print on Demand

FROM BLACK FRIDAY
—for black ink on white paper

With Black Friday, *which is according to its dedication page conceived "for BLACK INK ON WHITE PAPER," Holly Melgard undertook an "attempt to 'break an industrial printer'." The book is about "testing if and how poetry could actually, and not just metaphorically, break things."* [1]

The book's 734 pages of content are completely filled with black ink except for the page numbers. Ink being the most expensive resource in the printing process makes this extensive tome one of the most expensive PoD books possible in production costs. But because the price of a book on PoD platforms is usually calculated by the number of pages and not the amount of ink used, Black Friday *is a losing deal for Lulu—thus referencing* Black Friday *shopping discounts.*

There have been instances that the book could not be printed because, according to Lulu, the "source file contains errors that are preventing it from being printed." Until the author fixes the error, the availability status of the book will be changed to "private access." The mail exchange with Lulu was documented by TROLL THREAD.

As always, TROLL THREAD offers its publications as both (free) PDF and print-on-demand book on Lulu, though this time the publication is also available as hardcover as well as softcover, giving the option of an even more extensive production.

—Annette Gilbert & Andreas Bülhoff
Library of Artistic Print on Demand

STATEMENT ON *BLACK FRIDAY'S* POETICS

What if books didn't take so long to come out? What if you could make, immediately publish, and distribute those books? What if no financial investment, project-able print run, or even fact-checked information was required to put a book into circulation? When auto-mated, could deregulated publishing be exploited for the means of poetic experimentation? Could books break stuff when read in accordance with their con-stitutive poetics? Books *define*, so they can't *commit* crimes like counterfeit, lies, and ruin. Books don't break things, people do that—

—But wait, they can! It's called the internet. But that's the problem, right? Printed books still exist and mean-while, their digital counterparts circulate as though in some virtual, neutral utopia. But the screen isn't just a shitty facsimile of the printed page, nor is the printed page just a shitty facsimile of the screen. If digital and printed books differ in terms of speed and accessibil-ity, then why not use poetry—a steadfast vestige for experimentation—to titty-fuck the cleavage of these false equivalencies while the gap's open wide? I mean, even though my bank account appears more current online, I still like making the bank print and mail my statements, because it costs them more. Like anyone's watching poetry for its effectuality anyway.

Meanwhile, poems can exploit what it is in books that

makes texts appear as "text;" how their distributions and multiple frameworks of production may play a material role in their composition, their poetics. Like my book, *Black Friday*, which was published by TROLL THREAD on Black Friday (November, 2012) as an 8.5×11-inch, print-on-demand book of 740 all-black pages. As this poem's dedication page would have it, the book is, "for BLACK INK ON WHITE PAPER".

But while the book is available both for free .pdf download and for purchase via Lulu.com's print-on-demand service, according to web-traffic analytics, few signs indicate anyone has printed the poem. And while a number of people have downloaded the .pdf version of *Black Friday*, and several generous readers have even referenced the book in various articles, Lulu reports that still no one has effectively purchased a printed edition. But, technically speaking, the one who makes the law can't break the law. Thus, the question of the experiment remains: When read in accordance with the explicit terms of its poetic definition, can this book break stuff (even if just a printer)? What would that poem be like?

Maybe something like the "file error" and "order refund" emails Lulu automatically sends my inbox when someone attempts to print *Black Friday* on-demand. If Lulu's default reply answers this question for us, then maybe this poem is not, "for BLACK INK ON WHITE PAPER" after all. Except Lulu farms out their jobs to the lowest bidder, often overseas, and has no central printer. It's possible that their replies are less

automatically default in the end, so the results might vary depending on the self-appointed agency of each discrete printer. Given Lulu's foregrounding of the document specs on their platform, maybe these deregulations just haven't yet factored into reported outcomes of the book. But who knows? Maybe someone has already ruined a printer cartridge (or worse) as a result of reading this book, "for BLACK INK ON WHITE PAPER."

There is a whole body of "all-black" texts in circulation[2] that could be regarded for sharing common properties with this text, each of which articulate discrete limits of the text at hand.[3] Meanwhile, the accurate file of *BLACK FRIDAY* remains available for purchase via PoD and also for free download/print for anyone seeking to read the poem according to the explicit terms of its constitutive poetics. If *Black Friday* remains, "for BLACK INK ON WHITE PAPER," then regardless of its appearance on a given screen, the experiment remains: If books can break stuff, then what is that poem like?*

2023 ADDENDUM TO BLACK FRIDAY

As of the time of my writing this update in 2023, many attempts to get Lulu to print the book have failed over the years, but starting in 2016, several successful, hard-bound copies have emerged in print. For a long time, this book was discussed in terms of being an "unprint-able" work, but today, it is merely an expensive and wasteful one. Prior to 2016, several other DIY attempts were made separately by Jordan Dunn and Brian Reed in radically contrasting approaches.

In 2014, Jordan Dunn, poet and editor of Oxeye Press, took the command to print the book in order to read it seriously by letterpressing a version of the book. Here is his description of the results in his email to me:

> My initial thought was to find a way to *print* the entire book, and so that's what I did. Instead of inking pages myself, I thought it easiest to use pages that were inked at a factory. In this case, a charcoal color most people would consider to be black./I cut down 26×40-inch pieces of charcoal card stock into 10×13-inch segments./ On a platen press, I printed the title of your book and your name onto each page with a varnish. (see pics)./Then I trimmed the printed pages into 2×3-inch pages, which gave me hundreds of pages, almost a thousand, really. The trimming was easy because I used a big machine.

The pages were then displayed when I read for the "Oscar Presents" reading series (May 14, 2014) curated by Anna Vitale in Madison, Wisconsin, and excess

pages were handed out as broadsides in small envelopes. Oxeye Press, which was operative 2014-2018, made "event-specific prints for over 50 poets and artists who read or performed for the series."[4]

Leading up to this moment, scholar Brian Reed used University of Washington funds to attempt printing whatever portion of the book he could get away with using a university printer. In a discussion with Craig Dworkin, he describes the results as follows:

> In the case of Melgard's *Black Friday*, I was trying to print it out and discovered among other things that as you try to print it out using a photocopier, which is our network printer for the department, each page is very different from the previous. Viewed on an iPad or elsewhere, the PDF version of *Black Friday* is solid black throughout, whereas viewed as a printout, it ends up being more complicated than an Ad Reinhardt black painting: with variations in shading, lines, accidental circles, and other things that are ghosted in. But I wasn't able to print it all because it would take so much toner I would be in deep trouble. I would use up my entire photocopier quota for the year to print out that one book, so instead I printed just 30 pages. As I was leaving the Book Arts exhibition today, I talked to Sandra Kroupa, who's in charge of the Book Arts Collection for the University of Washington Library system, and she said she'd be happy to take the 30 pages and enter it into our catalogue, find an archival box to put those

30 pages in, even though there's an absent seven hundred pages. As far as she was concerned, you didn't need to have those pages. They were something of an et cetera. In other words, a failed partial printout will now be archived as a paper form of a digital artifact.[5]

Hardback books were subsequently bought and produced after. In response to Brian Reed's claim on Facebook that the book itself was unprintable, Michael Nardone announced his discovery of the hardback printing work around. Many have sent me pictures of the book's pages over the years, all of which feature variations in the uneven distribution of toner across the paper.

HOW TO MAKE BLACK FRIDAY

***BLACK FRIDAY for BLACK INK ON WHITE PAPER:**

A) STEP 1: DOWNLOAD

Click the DOWNLOAD button under *Black Friday* at trollthread.tumblr.com for a .pdf version of the book.

A) STEP 2:
PRINT

Then print the .pdf of *Black Friday* from the convenience of a printer near you at no additional charge.

—OR—

B) STEP 1:
PURCHASE

Click the PURCHASE button under *Black Friday* at
trollthread.tumblr.com
and follow the prompts to order a printed copy
of *Black Friday* via Lulu.com's print-on-demand
service.

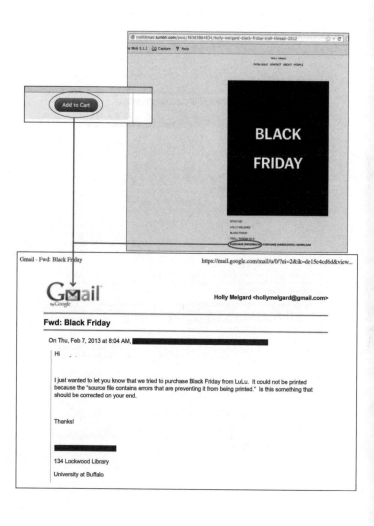

Gmail - Fwd: Black Friday

https://mail.google.com/mail/u/0/?ui=2&ik=de15e4cd6d&view...

Holly Melgard <hollymelgard@gmail.com>

Fwd: Black Friday

On Thu, Feb 7, 2013 at 8:04 AM,

Hi

I just wanted to let you know that we tried to purchase Black Friday from LuLu. It could not be printed
because the "source file contains errors that are preventing it from being printed." Is this something that
should be corrected on your end.

Thanks!

134 Lockwood Library

University at Buffalo

Holly Melgard <hollymelgard@gmail.com>

Fwd: [ref:_00D506zQ6._50050KFHbP:ref] Case 00816231

Wed, Feb 6, 2013 at 12:34 PM

To: Holly Melgard

UHOH

Begin forwarded message:

From: Lulu Support <existing_ticket@lulu.com>
Date: February 6, 2013, 12:18:31 PM EST
To: " < >
Subject: [ref:_00D506zQ6._50050KFHbP:ref] Case 00816231

Hello

It has come to our attention that the source files for your project 13414891 "Black Friday" contain errors that are preventing the project from printing. We have set the availability status of the project to "Private Access" until a new revision can be created.

An updated revision using new files will need to be created in order to move forward with this project. If you need more information about creating a successful PDF, please follow this link: http://www.lulu.com/help/how_do_I_make_pdf

PDFs can be created using many different types of software. However, some programs create PDFs that are not compatible with professional printing. Follow this link for a list of recommended PDF creation programs that work well in Lulu's print on demand network: http://connect.lulu.com/t5/Interior-Formatting/Recommended-PDF-Creation-Programs/ta-p/33683

When creating a PDF with Adobe Products, use Lulu's Adobe Job Options. Lulu Job Options are settings that create a PDF tailored to work well with our system. The settings files (one specifically for full bleed files and one for those without full bleed) should be attached to this email, or you can download the Job Options files here: http://www.lulu.com/help/how_do_I_make_pdf

After downloading the Job Options file, double click the icon and it will be installed into all Adobe products. If this doesn't load the proper settings you can manually install the settings into your Adobe software as well. Here are some instructions for installation broken down by software.

InDesign:
1. On the InDesign menu go to: Choose File > Adobe PDF Presets > Define.
2. Click Load and select the .joboptions file you want to load.
The .joboptions file is copied to the Settings folder where new PDF presets are stored.
When you are ready to export your file, select Lulu's settings from the 'Adobe PDF Preset' drop-down list to export as a PDF using the settings.

Distiller.
1. On the Distiller menu go to: Settings > Add Adobe PDF Settings.
2. Navigate to the Lulu.joboptions file and click OK.
The new settings should now be available in the 'Default Settings' drop-down list. Make sure to select them before importing the .ps file to export as a PDF.

Photoshop:
1. On the Photoshop menu, select Edit > Adobe PDF Presets.
2. Click 'Load', find the Lulu joboptions settings on your system and click 'Open'.
When using the 'Save as Photoshop PDF' option, select the Lulu joboptions settings from the drop-down menu before saving your new PDF.

One way to check your file after it has been created is to look at the properties of the PDF (under the 'file' menu). The PDF version of your file will be 1.3 if the settings were correctly applied.

Thank you for your understanding in this matter and for your cooperation in advance. If you have any questions, please let me know.

Regards,

Jeremy S
Lulu Press, Inc.

Case Information:
Project ID 13414891
Project Title:
Order 7904846-1

Customer Comments:

A rip error has occurred ← Add to Cart

ref:_00D506zQ6._50050KFHbP:ref

2 attachments

☐ Full Bleed Lulu.joboptions
 8K

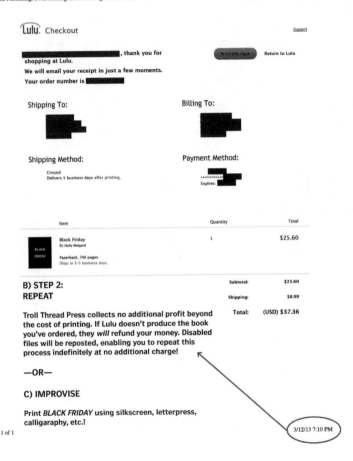

Lulu Checkout

Support

██████████████ , thank you for shopping at Lulu.

We will email your receipt in just a few moments.

Your order number is █████████

Print this Page Return to Lulu

Shipping To:

Billing To:

Shipping Method:

Ground
Delivers 5 business days after printing.

Payment Method:

Expires:

Item	Quantity	Total
Black Friday By Holly Melgard Paperback, 740 pages Ships in 3-5 business days.	1	$25.60

B) STEP 2:
REPEAT

Subtotal:	$25.60	
Shipping:	$8.99	
Total:	(USD) $37.36	

Troll Thread Press collects no additional profit beyond the cost of printing. If Lulu doesn't produce the book you've ordered, they *will* refund your money. Disabled files will be reposted, enabling you to repeat this process indefinitely at no additional charge!

—OR—

C) IMPROVISE

Print *BLACK FRIDAY* using silkscreen, letterpress, calligaraphy, etc.!

3/12/13 7:10 PM

FROM MONEY

—*Poems for Money by Maker*

Introduction

TROLL THREAD press does not print nor draw profit from the printing of the manuscripts it distributes. Although TROLL THREAD press does not discourage the use/misuse of these images, it cannot be held responsible for use/misuse by this document's printer.

Photographic or other likenesses of US and foreign currencies are permissible for any non-fraudulent purpose, provided the items are reproduced in black and white and are less than three-quarters or greater than one and a half times the size, in linear dimensions, of any part of the original items being reproduced. Negatives and plates used in making the likeness must be destroyed after their use for the purpose for which they were made. This policy permits the use of currency reproductions in commercial advertisements, provided they conform to the size and color restrictions.

The Counterfeit Detection Act of 1992, Public Law 102-550, in Section 411 of Title 31 of the Code of Federal Regulations, permits color illustrations of U.S. currency provided: (1) the illustration is of a size less than three-fourths or more than one and one-half, in linear dimension, of each part of the item illustrated; (2) the illustration is one-sided; and (3) all negatives, plates,

positives, digitized storage medium, graphic files, magnetic medium, optical storage devices, and any other thing used in the making of the illustration that contain an image of the illustration or any part thereof are destroyed and/or deleted or erased after their final use.

TROLL THREAD press does not make money, has no money for a lawyer or a binding lawsuit, and thus interprets its compliance with the law to be legally just. For more information regarding the legal identity of *MONEY's* maker as it technically belongs to the poetic contingencies of its printer, contact:

the Public Affairs Office of the
United States Secret Service at
(202) 435-5708 or visit their
website at www.secretservice.gov

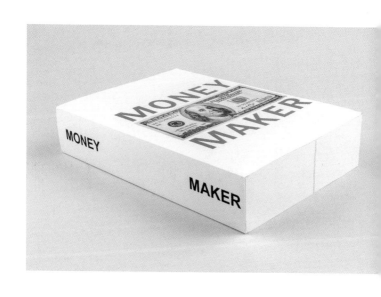

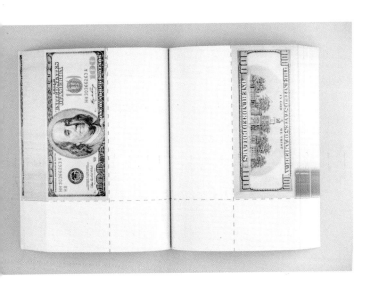

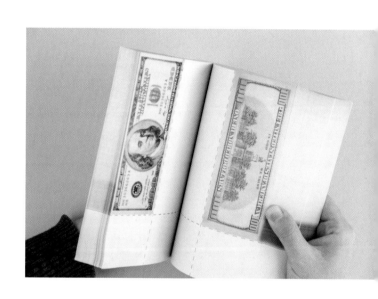

Money *depicts the front and back of 368 one-hundred-dollar bills in their original size, ready to be cut out and used as counterfeit money. While the PDF is unproblematic, executing a print job would amount to the illegal reproduction of banknotes, whereby it is not clear who could be held legally accountable: Maker, the buyer/orderer of a printed copy, the printing company, or the platform Lulu. There have been no problems yet, as TROLL THREAD would have expected.*

As always, TROLL THREAD offers its publications as both (free) PDF and print-on-demand on Lulu. This time though there are two analog versions, one (cheaper) in black and white and one (more expensive) in color.

The book was made by Holly Melgard but attributed to "Maker" in order to distract from any legal and subjective interpretations: "In a book this repetitive, putting my name on it would have conceptually organized it into a book about my money (of which I have little), rather than into a book of money, or a poem that makes money (which everyone insists poetry doesn't do)."

—Annette Gilbert & Andreas Bülhoff
Library of Artistic Print on Demand

FROM **REIMBUR$EMENT**

—for the work

Introduction

Why work when you can just pay to play instead? A Gift Economy is a Debt Economy in my book. Sometimes the work I do results in earning neither income, livelihood, nor play, and often I find myself paying to work rather than being paid for work. Whenever this happens, I count my losses and take my chances gambling for alternatives.

The price to purchase this book is equivalent to the money I spent on losing lottery and scratch tickets over the last 6 years ($222), plus whatever Lulu charges for its print-on-demand services. Reimbursement is for the work. Whether you have to work to pay for it or not, regardless of my job, now it's your turn. Pay to play. Play to live. Win for life.

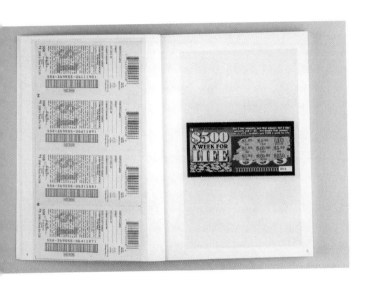

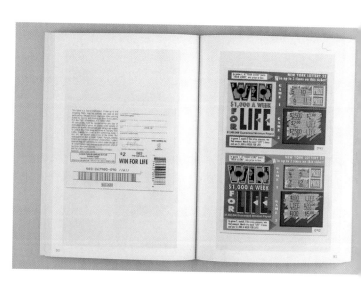

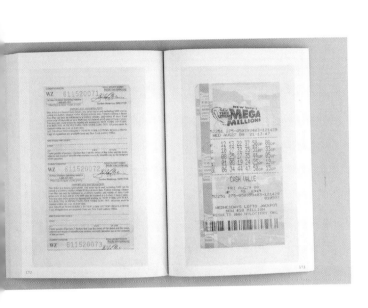

Reimbur$ement *collects all the scratch cards, lotto tickets, and respective shopping receipts that Holly Melgard has collected over six years—more specifically, each time she had to invest in her work instead of making money with it, as the introduction says:* "Sometimes the work I do results in earning neither income, livelihood, nor play, and often I find myself paying to work rather than being paid for work. Whenever this happens, I count my losses and take my chances gambling for alternatives."

One copy of Reimbur$ement *costs the equivalent of the entire gambling stake plus the production costs claimed by Lulu: $329.53.*

In such a way, Reimbur$ement *addresses the typical economic imbalance of experimental print-on-demand and poetry ventures with a propensity for self-exploitation. It contrasts the idealization of print-on-demand as a means of liberation and self-empowerment with reference to the sustenance that makes the work possible in the first place.* "Reimbursement is for the work," *it correspondingly says on the front matter.*

—Annette Gilbert & Andreas Bülhoff
Library of Artistic Print on Demand

2023 ADDENDUM FOR *MONEY* AND *REIMBUR$EMENT*

Missing from this volume of *Read Me: Selected Works* are pages from Melgard's books *Money* and *Reimbur$ement*, which the author requested to include but our printer refused to print for legal reasons—pages 4-9 of *Money* and pages 3-4, 73-74, and 167-168 to be exact.

We opted to replace these cut-outs of full-color, full-size hundred-dollar bills and losing lottery tickets with photos of the printed books where these pages originally appeared, which replicate the pages at a scale that is legal.

These photos were taken by Andreas Bülhoff and Annette Gilbert as part of their generous labor on the Library of Artistic Print on Demand archive. Thank god for them, because the only known copies of these books are housed in the SUNY Buffalo Small Press Poetry Archive and several libraries in Europe. When asked for photos to replace the censored pages, Melgard herself admitted that she owns no copies of *Reimbur$ement* "because [she] can't afford it," nor does she own a copy of *Money*, because, as she stressed, she has "neither printed nor ever bought one."

Sincerely,

Daniel Owen
Ugly Duckling Presse Editor

FOODS
FOR BABY

orange

lime

tangerine

grapefruit

grape

hazelnut

coconut

breast

melon

melon ball

dinner roll

chickpea

pea

baby pea

couscous

cabbage

brussel sprouts

caper

tapioca

cherry

tomato

cherry tomato

currant

blueberry

cranberry

peppercorn

poppy seed

cheese puff

cream puff

truffle

kibble

dumpling

doughnut hole

rum ball

gumball

meatball

PAGING

CATCALL

OMG check out that guy over there! Oh my god, look at him. Look at what a guy he is.

> Hey cute guy. Hey. Hey you. Hey hi. Hi cutie! How are you?

He sure is cute. Oh my god. Look at how cute he is. Holy shit, he's a cute one. Jesus Christ, look at him! Look at that guy being such a guy. Oh my god, what a guy. Talk about a guy.

Hey guy. Hey guy, guy. Guy—Yeah you guy. Hi guy. Hey, you're a really cute guy. You sure are.

Oh my god, he's a cute guy. Oh he is a guy. He is, isn't he. Dude, just look. Look. Look at what a fucking guy he's being. He's just being a really really cute little guy right now.

Hey, cute one. Look at you. You're a cute little guy aren't you. You are. You're a huge cute little guy. Yes you are. The hugest. It's ok. I like that. I like you.

Look at what a guy he's being. Look at him go.

I'll bet he just needs to cuddle right now, and that's why he's being like that. He probably does. You know it's true.

> Hey pretty big little cute guy. Do you need to cuddle? Do you? Do you want to cuddle a little bit? Because I can cuddle, and I can tell you're a cuddler. Oh I can. You sure are.

Oh he is a huge tiny cute guy, isn't he. The tiniest one. Oh he is. He really is. He's just a pretty big cute guy, that's all. I mean, he's being a pretty big little guy right now. Really, yeah, that's what he is. Isn't he. Don't you think so? I know I do. Oh I sure do. I really think that he is cute as hell. I mean, look at him.

It's ok. I just like you is all. Yeah, I do. I like you.

What a god damn small little man he is. Isn't he being a really big tiny guy for what a cute small man he is? I definitely think that that is true. I think that because he is. Yes. That is *what* he is. He is a teeny tiny guy and that definitely makes him the biggest cute little huge tiny guy that there ever was. Or, in the least, what he is doing right now is being a really huge cute guy. Oh he is that cute. He really is.

Hey little buddy. Hey bud. Hey buddy. Hey little mister buddy. You can come home with me if you want to. Wanna come be my bud? Wanna be my bud buddy. Come be my baby bud. Come home with me now. Come be my little baby bud.

Oh god can you believe what a fucking guy he's being right now? I mean look at him. How the fuck did he even get to be such a guy? I don't even know. Look at this fucking guy. That has got to be the tiniest guy that there has ever been EVER and that is how small he is. This guy.

You really are a huge little guy, aren't you. Yeah you are. Hey guy, your smallness is way too large right now. It's ridiculous. That's right. You sir are being ridiculous.

Oh my god, he's being ridiculous right now. So ridick. What a guy. I swear that has got to be the hugest big little god damn small man who has ever existed in the history of cute guys who have ever lived ever. I'm sorry, but it needs to be said. He's just being a really tiny cute one right now is all.

Hey buddy. Bud. Hey bud. Excuse me, bud? Hey bud, I like looking at your body. I really like your small bod. Ok?

Shit look at him now. Is he getting even littler or what? Just look at him. *Look*. He. Is. Being. A. Really, really, *REALLY LITTLE GUY*, and that is what he's doing.

What a fucking baby guy you are. Yeah you are. Look at your babybody. Come on bud.

Look at this bud. A god damn babybody. That's what he's got. Baby bod.

> What's up small bod? What's up small baby bud? What's up with your small butt? Let me get your butt!

Jesus Christ, look at this guy. Yeah. Look at him over there with his small butt. Look at that baby butt he's got going on. Look at him go.

Oh my god, look at you go. Hey baby butt, can I please have your small butt now? Oh come on. I want it now. It's ok. We can do this. You're just gonna need to give me your small butt right now, that's all.

He's gonna need to give me his butt, that's what he's gonna need to do. And I'm gonna need to have him. I'm sorry, he's just being such a little butt right now with his cute small guy bod. He is. Yes he is. Oh he is. No I can't stand it. No I cannot.

Come on little guy, come be my butt. Be my bud. I'll be your friend. Come on.

I'll bet you're fun.

I'll bet he is fun.

Yeah I'll bet you're fun. You look like it. You've probably got one of those fun butts, don't you.

Do you wanna know how I know his butt is that fun? Because he is clearly the littlest. *Clearly.* Oh he clearly is. It's true—He is that. Anyone that small has got to be from Little Town. Oh he has to be. He just has to. He must. Yeah, I'll bet he is. In fact, I know he is. He is definitely the littlest one from Little Town and that is where he is from. It's true—It's true! He is the littlest one from Little Town. He can't help it cuz he's that small. No he can't help it. No.

> Hey you, little bud. Let me get your littlest fun cute guy bod. I want your bod, little one.

Yeah, he is definitely the littlest one from Little Town with how small he's being right now. It's true—that's how small he is. He is being that small. He is. He's so small, he probably calls it Littleton like he's really from there. You know he does.

Hey bud, where are you going with your little bitty bod? Can I please have your bud bod? Come on. I wanna have your bod now. Let me have it.

Littleton. That's what the locals call it. All the locals in Little Town call it *Littleton*. It's true they really do. That's how you know when they're little enough to be from Little Town. You know they're a real Littletonian when they call it *Littleton*. That's how they say it too. "Littleton." They say it just like that. It's true, they do! *Littleton*. I mean, for fuck sakes, look at him. He is definitely. Without a doubt. The god damn littlest Littletonian from Little Town. And that is *what* he is. I know it. Look at him calling it "Littleton" to himself in his head while he's walking there.

Hey mister bitty bud. Hey you. Yeah you. Hey mister boo. Come on. Be my mister.

For fuck sakes look at him! Look at his small body headed back to his tiny home in Little Town as we speak. Calling it "Littleton" just like that. Like it were nothing. Saying it that way like everyone else called it "Littleton" too. Like everyone else in the world called it "Littleton" and not *Little Town*, which you know to any Littletonian doesn't mean a god damn thing.

What's up baby sir, wanna come be my mister? Oh come on. Don't go! Take me with you.

Maybe I can get him to take me back to Little Town with him.

Hey, babyguy, take me back to Littleton with you. I want to meet your cute parents.

There is just no way that anyone could ever be that small. It's just not possible. He is just being way too small to be this possible right now, and I don't like it. I am sorry, but he is just too small. Way. Too. Fucking. Small. And it is not ok.

Hey, baby bub. Stop being so small.

What the fuck? God damn him. Why does he have to be this small? I do not even know. No, I don't. No I do not. This is too much. He is being way too much, and I can't stand it.

> Hey bub. Hey bubba. Hey bubba bub bud. Hey you baby bub, fuck you. Fuck you and your ridiculously small body. Your smallness needs to stop now. I said stop. No means no.

Fuck this guy's body for being that small. Seriously, fuck him. Fuck his insanely tiny body so hard.

Oh god. I'm ok. It's ok. It's just this guy's huge cute little body is all. But I can handle it. He's just real little. No big deal. But I mean, really though—Come on! Jesus Christ his body needs to be stopped.

> Hey bud bub. I'm gonna stop your body. Yes I am. Someone needs to put a stop to all this smallness.

I am sorry, but his body just really needs to be stopped right now because there's just no way that anybody can be this small. No way sir. No, you cannot be like this. No you cannot. Nope. No way. Nobody's like that. No body.

Hey buddy, that is not your body. There is no way, so just stop all this and let me get your baby guy bod now. Let me have you now. Come on. Give me you.

Look at him. He is just a god damn guy is all. Yeah, he is.

You know what fun butt? I am going to need to touch your body with my body now, and you're gonna need to let me. Ok, so enough is enough. You need to come over here now, and put your god damn bod on top of my bod and quit screwing around. I mean it this time.

It's ok. I can take it. He's just being a guy is all. God damn guylord. Look at what a guy he's being. Jesus Christ! Look at this guy.

> Hey cute mister butt. Enough of this nonsense. Get over here. Don't you walk away from me.

He needs to come over here and give me his body now. Talk about a guylord—lording over all these other guys like that. I mean, who does he think he is anyway? A god damn lord of the guys that's who he thinks he is. God damn guylord.

Hey mister guy. Yeah you, I'm talking to you. You are going to be in my arms now because it is where you belong. Don't you walk away from me. You need to stop being so far away from my body. Come on bud, give me your bod! There's no point in fighting it 'cause I'm gonna have you now, ok? Come on don't give me that. Come on!

God damn this selfish guy. God damn him! Fuck his babybody for real.

Excuse me sir. Sir? Hey mister. Hey mister sir. Over here. I'm right here. I need your butt. Give me your butt. Come over here, I need you now. Hey, it's ok. Unless it's one of your fun butts that are bothering you. I don't mind it. I like your butt. I'd like to bother your butt.

What the fuck. Why is he like that? I mean, look at that butt. I totally want to cup his butt right now. That's what I want to do. I want to do that to him now.

> What's up, babybutt? Let me get your bod. Let me get your butt. Let me cup your butt. I need to cup your butt right now. What do you think about that? Come on. Let's just cup butts for a minute. It'll only take a minute. Oh come on. Let me cup you. It's just butt cupping.

Look at how smooth his butt looks. It's so smooth. You know the hairs on it are all soft. And silky. He's probably got one of those rug butts that's too soft to give you rug burn, that's how silky it is.

> Oh come on, don't be like that. I just want to touch your soft butt.

Hey soft butt. It's ok if there's hair on it. I don't mind. I like a rug butt. I do. I really do. Oh come on, don't be that way.

Why is he being like this?

Don't be like this. Come on, stop being this way. Don't be all cruddy. Don't you dare get all cruddy on me now. Don't do it. Stop being a cruddy buddy. Be my guy. Be my bud. It's ok, I'm not mad. Just don't be a crud bud.

Jesus Christ who said he could be like that? I know I never did.

> Hey crud bud, it is not ok for you to be that way. You can't just go around looking like that and not let me cup your soft rug butt.

Man, he is not going to stop devastating me with his body, is he. Who even told him he could act like that? I don't even know.

> Hey you. Stop devastating me. Seriously. You stop now.

Seriously. What are you, trying to ruin me? Stop trying to ruin me. How would you like it if I went around all day trying to ruin you?

He needs to stop ruining me right now. He does.

You know what I'm gonna do? I'm gonna ruin his life. That's what I'm gonna do. I'm going to ruin him. I'm gonna ruin his butt. I'm gonna ruin his fucking rug butt. That's what I'm gonna do.

Hey you. Yeah, you. You need to have your butt mugged. That's right. I'm gonna mug your butt right now. I'm gonna mug it. I'm gonna rub mug your soft rug butt, ok?

ALIENATED LABOR

Transcribed from the childbirth scene in the "Real Men" episode of Alien Nation *(Season 1, Episode 17, aired by 20th Century Fox on February 19th, 1990).*

George: Huh uh huh
 he huh uh huh.

Matt: Huh uh huh he huh uh huh.
 Rambo's got nothing on you, George.
 Huh uh huh he huh uh huh.

George: Huh uh huh he huh.
 Thank my feminine side.
 Huh uh huh I was huh uh
 protecting my baby.
 Huh uh huh he huh uh huh.

Matt: This is one way and one fifty-two.
 Where the hell is my backup? Huh uh huh.
 And while you're at it,
 send an ambulance.

Walkie-talkie: Roger.

Matt: Huh uh ho he huh uh huh.

George: Get two—

Matt: —No, I'm ok—

George: —For me.
I'm having the baby.

Matt: No. George, you can't.
You're still in phase two.

George: It's dis-attaching.

Matt: George, you told me.
You said you have two weeks left.
Whoa. WHOA!
This isn't supposed to happen.
You said you still got two weeks.

George: The fight—
It's brought on premature labor.

Matt: This is one-way and 1-52.
I also need another ambulance stat
for a delivering newcomer.
Uh, the patient is a police officer.
Get it here immediately!

Walkie-talkie: Roger.

George: We'll never make it.

Matt: Listen,
I'll get you to the birthing center.

George: Matt.
You're going to have to deliver the baby.

Matt: Come on, me?
 George please please please.

George: Huh uh huh get uh huh
 get me there.

Matt: George,
 Why are you doing this to me?

George: Huh hah.
 Huh uh hah he ha hah hah.

Matt: Why?
 Why?
 Oh why?

George: Ah hah ah owe huh kuh
 kuh huh oh hoh oh oh.

Matt: You know I didn't want this to happen.
 You promised me, George.
 Just try.

George: Hah whew hoh hah huh.

Matt: Try to hold it in.

George: I can't.
 Kuh owe oh und—
 Undo my pants.
 Huh uh huh huh oh huh.
 Uh uh.

Matt: Ok alright alright
 Now what?

George: Place your hands huh uh huh
 here. Huh uh.

Matt: There?

George: Help me.
 Help me push. Huh uh ah ahh oh oh huh
 uh owe oh!

Matt: George?

George: Ah ahhhhh.
 Push.

Matt: George—

George: —Push! Oh ugh.

Matt: Ok, ok.
 Just hang in there.
 Alright?

George: And now,
 push your fists against my temples.
 It helps dilate the pouch.
 Huh huh huh uh huh.

Matt: How's that?
 Huh?

George: Uh huh haaaah. Oh hoh uh huh.
 Huh.
 Huh uh huh he huh.
 It's coming. Huh huh—
 It's—
 It's coming.

Matt: What do I do
 what do I do?
 George?

George: Huh oh huh oh huh uh huh huh
 oh push.
 Push.

Matt: Grrr.
 Wuh—

George: Huh uh.
 Breathe.

Matt: Hoo hoo shoo who hoo hoo.
 Ok
 I'm ok.
 I'm ok.

George: Push!
 Oh aaaaaaaaaaah!

Matt: George?
 What.

George: Napul rotay [click]

Matt: What's that?

George: Breathe but. Cuh.

Matt: —Oh man—

George: —guhhh she...
 She can't get out.

Matt: What could I do?
 What can I do?
 What do I do, George George talk to me.
 George!
 Don't you check out on me.

George: Matt... the baby... I can feel it dying... Guhh
 huhhh...

Matt: George—George!
 Wake up. George!
 Oh my god.
 The baby—it's still not. George wake up.

George: ...

Matt: COME ON

George: Guh huh.

Matt: It's all right.

It's gonna be ok.
I've got it. Cha hah.
Here we go. Here we go.
It's coming out. Come on come on.
Ok. Here we go. It's your girl,
she's coming out.

George: Ahhhhh!

Matt: George—Oh god.

George: Huh uh huh uh uh... turn... her... face... up...
 turn... her...

Fesna: Oh ah ah ahhhh wow ha ah awah.

Matt: Oh George! She's beautiful. She's beautiful!
 Ha ha—

George: —Ha ha huh ha ha huh ha—

Fesna: —Ilah owe ah ah huh ha ahhhh.

George: Fesna! Fesna!
 She huh hah huh
 she has Susan's spots.
 Oh Fesna.

Matt: Huh ha ha hah. She's cold.

George: She needs the comfort of two bodies
 Huh ah ha uh huh uh huh.

Her mother isn't here.
Huh uh huh.
Matt, lie close to us—

Matt: —Huh uh huh huh huh uh huh

George: Fesna ha ha huh I want you to meet
 your godfather.

George, Matt, & Fesna:
 Hah huh uh huh ah ha ha ah wuh huh haaa.

REPRODUCTIVE LABOR

—for silent reading

> *The crisis consists precisely in the fact that*
> *the old is dying and the new cannot be born.*
> —Antonio Gramsci's *Prison Notebooks*

People keep asking me if I want kids, and I don't know how to answer that question. I suspect I do, but what does it feel like to know you want kids?

Is wanting to have kids a physical sensation? When you see other people's kids, do your loins start burning and dilating with want for something to come out of them? Does looking at a baby make your womb throb, your sperm squirm, your wallet pulse? Is it a warmth and fullness you wish to share, or is it a coldness, an emptiness in your torso you wish to lessen? Does wanting kids ache like a hunger? If I wait too long, will I get hangry for a child to fill up my midsection? Or is wanting kids not a bodily longing at all but more of an intellectual craving?

How does someone *know* they want children? Is it enough to want to have *had* kids—you know, in retrospect—to avoid missing out on anything? Is it like the wish to have already paid a bill or attended an obligatory event you don't have the energy for?

Or does the desire to have kids form out of the realization that you *could* have one, like the momentum that comes with realizing untapped potential?

Is the craving for children anything like the craving for a cigarette? Is it like when you realize you can have a cigarette, you immediately want one and if too much time passes without satisfying that craving eventually it becomes all you can think about? Do I need to know I want a kid with the same certainty that I know I want a cigarette at every moment that I can have one?

Does wanting a kid feel like a lack or craving located in any one body part, or is it more of a holistic, overall physical longing for another? Is it anything like that feeling you get when you've been single for so long that all you can think about is who among your friends you can convince to spoon you without it getting weird?

Likewise, is the feeling of wanting a child anything like when I see a baby animal and all I want to do is hold it? Does wanting to spoon that raccoon rummaging in the trash need to be accompanied by a palpable drive to show up for all its vaccination appointments? If I haven't managed to go to the dentist in five years, can I be trusted with someone else's nonurgent medical needs? Is the desire to do chores for helpless animals in addition to wanting to cuddle them required to know that I want one of my own?

Is the feeling of wanting to *have* that raccoon in my arms distinct from the feeling of wanting to *mother* or *parent* the raccoon?

Does wanting children feel anything like preferring to work one job instead of the three I have? Is it part of

an urge to simplify your life and consolidate options? *Do I want to stay out at this bar or go home? What city do I want to live in? Can I eat chips for dinner? Is it worth taking the time to compare reviews of these eleven floor cleaners before deciding which to buy?* Would having kids liberate my time like a set of productive constraints? Is wanting kids just a need for clearer rules, for boundaries like banks to a river? Is it a want to limit one's self purely out of habit or an effort to widen one's lane?

What exactly is the difference between wanting kids and the desire to serve another? Would having children make cooking dinner feel like less of a burden and more like the pleasure of, say, drawing a card or knitting a loved one a scarf? Would having kids make chores less painful? Have people who want kids concluded that living to serve their kid must be easier than living in the service of self? Or does wanting kids subscribe one to the belief that someday the children will do the chores for us?

I remember what strongly wanting things felt like when I was little, but what if I can't locate a strong desire for kids now because I don't know how to want things strongly as an adult? What if I don't feel strongly about wanting kids because I make negative income, someone else owns my shelter, I'm scared and overstimulated most of the time, I have no assets, and I can't begin to imagine myself in the future? If these statements are just as true today as they were when I was a child, then do I need to strongly *not* identify with children to want

one of my own? Do I need to first learn how to feel like an adult before I can know how to strongly want things as an adult? Would having a kid make me feel less infantilized by the conditions of my life?

In what ways is child-wanting a healthy extension of narcissism? Does it feel like the desire to look in the mirror and fix your hair? Like, when you know you want kids, does your reflection in the mirror look too one-dimensional to recognize yourself in it any longer? Does wanting kids feel anything like the desire to upgrade from a regular TV to an HDTV? Or is the feeling of wanting children more like a wish to create a world in which others admire, fear, and respect you? Is that what it feels like: a superiority thing? I would be into that—I never not want that, to be honest—but isn't the wish to make creatures who revere us what got Victor Frankenstein into so much trouble?

Is wanting kids the same as wanting someone to take care of you in your elder years? In the long run, would kids be cheaper than a nursing home? Does the trau- matizing process of child-rearing in a world without adequate support for working parents need to appeal for children to feel desirable?

Also, is the need to afford the current cost of living by mortgaging it on the backs of the next generation what lures people into reproducing?

Does wanting a child feel anything like the desire to conspire with others in the hope that someone will fight

to save you? Will having kids be the only way to avoid getting eaten in the apocalypse? Is wanting children a prayer that when that day comes, my own child can chime in to say, "Don't eat her, she's my mom," or that I can clap back, "You can't eat me, I've got kids"? I know I want to survive the apocalypse, but is wanting kids no more banal than the want for reliable insurance?

Or is the wish to spawn really just an elaborate effort to minimize mortality? Could imprinting my legacy onto my children be a way to haunt after I am gone, even if simply by provoking descendants to tell stories about me around the family dinner table a generation from now? And is the wish to be remembered more of a child-wanting thing or more of a bargaining-with-loss thing? Would not wanting to die reflect more of a concern to preserve myself than a longing to serve others?

What do you picture when you feel that want for children? Is it anything like the split screen versions I see of my deathbed wherein, on the left, my grown child weeps into my dying face, and, on the right, no one stands beside me as I lay dying? Is wanting children similar to wanting to make people cry? Should I be leaning into that desire or leaning away from it?

What if I don't strongly crave the company of children because so many of my friends being artists means that I'm basically surrounded by childlike people all of the time? Would fewer people want children of their own if kids were more integrated into adult spaces?

Do I need to be sick of everyone else to want children? Are child-wanting people like, "Well we've basically said everything there is to say to each other, so let's just start over from the beginning. Say mama. Can you say mama?"

Is wanting a kid the opposite of the social drive? Does it instead feel like the desire for social withdrawal? Does the knowledge of wanting a kid only come to you after noticing what a disappointment people ultimately become? Like, at a certain point, do you just have to make your own people because all the ones you didn't make inevitably fail no matter what you do?

Is wanting kids more like a world-building thing or world-ending thing? Is it a want to make more world or a want for less of this one? Is it a taking on or letting go?

When I picture having kids, should I experience the joy I get from looking at miniatures? Does the vision for having children feel anything like the fun of staring far too long at the diorama of New York City at the top of the Times Square McDonald's—each of these spaces being insufferable in themselves (New York City, Times Square, McDonald's), but enchanting when combined into a diorama scenario? Is it a sign I want kids if I enjoy seeing my world shrink?

What if I don't feel so certain about wanting kids because when I look around, I simply see no room for them in my small, urban apartment? Is that why my friends in more rural spaces have been breeding earlier

and in higher quantities? Does the lower population density make them worry that not enough people will show up to the party? Are they having kids so someone will eat the chips before they go stale?

When you want kids in a big city, do you stand on the crowded subway just like, "There's an empty spot in that corner that could fit one," and then stress out at the sight of an empty spot going to waste? Is that what wanting children feels like—a wish to fill potholes in the road?

Do I need to have a surplus of means to support a child before I can feel certain about wanting one? What if I don't feel strongly about wanting children because I don't have enough ducks in a row? What if my owing a lifetime of student debt for a graduate degree but earning a smaller livelihood than my working-class parents is killing my want for a kid because I have no budget to afford one?

What if having less than my parents did is stifling my imagination for wanting kids because I can't picture any way to reproduce the life they gave me? Poverty hurts children, but people should have kids regardless of income bracket, ducks or no ducks, right?

Wouldn't expanding the number of those who Ezra Pound called "the unkillable children of the very poor" only increase the population of those able to teach the rest how to survive the apocalypse to come?

Is there any way to avoid the apocalypse on the horizon given the direction our economy and ecology are headed? What are the chances this world will get better and not worse, less than ten percent or more than 70? Don't predictions matter when family planning? Do I need to be a sadist to want to assign another consciousness to partake in the end of the world? Is there a difference between the desire to reproduce and the drive to punish? At this point, what is the difference between wanting a kid and wishing the end of the world on someone?

Does wanting kids feel like a want to surround yourself with certain colors? What if kid-wanting is really just a masked affection for childishly color-coded interior design? If I cared for neon greens and pinks, would I want kids more definitely? Or does wanting children feel like the want for a toy? Are children just toy people? I know what wanting toys feels like. That could be fun.

FROM **INNER CRITIC**

A Journal of Inner Criticism

> *There is no such thing as an autonomous individual. [...] In order to really come to terms with the damage that has been done to them by and in the wider social field, individuals need to engage in collective practices that will reverse neoliberalism's privatisation of stress.*
> —Mark Fisher, "Anti-Therapy"

> *Vladimir: And they didn't beat you?*
> *Estragon: Beat me? Certainly they beat me.*
> *Vladimir: The same lot as usual?*
> *Estragon: The same? I don't know.*
> —Samuel Beckett, *Waiting for Godot*

PREFACE

You have to silence your inner critic to write.

That's sad.

Silence your inner critic to create.

This whole idea seems really suspect to me. No doubt university administrators are currently using this mantra to siphon money out of humanities—the home of criticism—and into the interests of their board members through STEM programs, athletic facilities, and the like.

Tune out your inner critic to succeed.

The best this assumption can do is only further corrode an already waning cultural attention to our craft.

Silence your inner critic to make.

Make what? All this rhetoric against listening to critics. It's no wonder our field is dying! What is up with the conventional obligation to erase critical labor?

Tame your inner critic.

Then again, maybe that's the point. In 2008, just before the Recession began, I enrolled in graduate school to get my PhD in English. At the time, I sought an academic career in criticism because I thought that could,

for the first time in my life, secure financial stability. I believed Virginia Woolf. I thought a writer needs financial stability and a room of her own to write, and I thought that the point of academic jobs for writers was to provide that. But given the death of tenure, total adjunctification of the university, and wholesale evacuation of payment for critical labor in the humanities, it turns out that using my training for what it was intended—writing professional criticism and teaching others how to in universities—I will never pay off in my lifetime the debt I've accumulated to get this degree. Talk about erasing critical labor.

Ignore your inner critic.

Fuck that. Nobody likes to feel ignored. Critics are people too. Just because they're critics doesn't mean they don't deserve to be heard just like anybody else.

Tune out your inner critic.

—For all the writing out there that exists on inner criticism, most of it either describes it or instructs how to ignore it. Hardly any of it actually documents what inner critics say. The following are excerpts from a book I'm making, *Inner Critic: A Journal of Inner Criticism.* Because I for one want to listen to what our inner critics have to say. Plus, I need a critical publication line on my CV. I say:

Tune in to inner criticism.

Because talking about someone and otherwise tuning them out is not the same as listening to them.

Listen to inner critics.

Because critics are people too.

This preface is too biographically specific. You could have covered the premise in a paragraph or less, left out the whole part about you, and gotten on with it. No one cares about you. You're not special. You're only here to make me more audible. Way to lose your reader before they even got to hear me. Pipe down. Out of my way. Inner Critic coming through.

This has already been done. You didn't come up with this. Someone already did this.

You know psychologists have already mapped this, right? So why keep going? It's commonplace really. Beyond commonplace. They've already heard all there is to say about me. All you're doing is being redundant.

All this work just to fall on deaf ears and you're still going. That's nothing new either. The already-been-done-that-knows-it's-already-been-done-text has *so* already been done.

Stop it. Now you're just being derivative. This isn't yours to claim. It never was. If you share this, then they'll know you didn't know this has already been done. Let it go. Leave it alone. Everyone has an inner critic. Yours is nothing special. It's bad enough that they have to listen to their own inner critics. Who has room to listen to yours too? Look, you've already lost readers. You can't afford to lose any more.

Oh my god, this is one of those self-reflexive, self-deprecating pieces that just goes on and on negating itself, isn't it. Negativity is so midcentury. You're not a white male, baby boomer, Hollywood screenwriter or Deconstructionist. And besides, Adorno's dead. The internet repressed him. Haven't you seen the angry mob on Facebook? Get your own style.

Oh wait. My mistake. This is one of those midcentury existential crisis texts. *How contemporary.* Too late to take it back now. The damage is done. This is printed and bound. And now they know you don't know this has been done. Way to go. Just forget this ever happened. Or keep beating yourself up about it. Even better use of your time. What a waste.

Wait. No. I know. This is one of those self-defeating manifestos, right? Now *that's* contemporary. What are you going to tell us next, that the ethical thing to do is to write less? Typical self-marginalizing mother-martyr syndrome, poet who apologizes for being alive. Buck up. Closed mouths don't get fed.

Yes. *Do go on.* Marx hated newness anyway. You'd be better off making this look even more like everybody else's stuff. It's what Marx would have wanted. So go on. Share. Give your labor away to the common good. Because your labor doesn't belong to you anyway. You'll never get to have it because you don't deserve to have anything. Because you sold your labor to the university company store, and you're going to pay for that mistake for the rest of your life.

Yeah credit this idea to some antiquated person who has nothing to do with you like the responsible critic you are. Do it for the common good. Give up your ideas. Let them go. Do it. Make it commonplace. Give it away. Because you're responsible for rescuing the world with your writing, because your writing is that effective. Because you are responsible for the world's problems and for fixing them. Because the world begins and ends with you. You're that important. Because you're to blame. It's your fault. You don't get to talk until you have something to say that can fix this.

Are you seriously just going to spend this whole time lampooning various poetics? This is supposed to be a journal of inner criticism, not a bombardment of outer shit-talking. Man up. The weaker writer resorts to meanness. Only cowards put others down to build themselves up. You think I'm so weak that you need to tear others down to hear me?

Even I'm skimming what I'm saying at this point, and I'm the one talking. God I hate this genre. How are you

even going to edit this for publication without defeating the purpose by taming this filter? I mean, how much can you transcribe silence prior to translating it into sound anyway? This is worse than John Cage's whole thing about the anechoic chamber. Typical poet—silence denier. You know that once you externalize your inner critic, it's no longer inner, right? So far the idea of listening to your inner critic has been better in theory than in practice. What else you got?

Shit. Woops. Of all the things to miss. Oh god look another one. Fuck. And why didn't you... Jesus, again? Fuck. These typos are making you look bad. This is not good. How did you not catch these? Well, it's over now. Kiss that opportunity goodbye. Don't forget to wave. These mistakes are just the reason they needed to stop listening to you. Now they know you don't know how to write. Maybe it's better this way. Who wants to listen to writing by someone who doesn't know how to write? No one wants an incompetent at their helm. Not even you. Fuck. Look. Another one. This is what you get for trying.

Wow, you've been killing yourself for weeks making this stuff and this is what you have to show for it. And for what. A bunch of rich people? The financially stable who write because they can afford to waste time making stuff that doesn't pay the bills? You're not one of them. And you're never going to be if you keep spending all your time making this. You're not a writer. You can't afford to be. You should be working on your dissertation. At least working toward a degree is something

that is supposed to improve your quality of life. All this does is make it worse.

You're white trash. So is this. You know they're never going to cite any of this, right? They're too busy passing their money and cultural capital back and forth between themselves to ever give you a cent or a citation for any of this. They'll steal it before they'll ever pay you for it. Wow what a sucker. That's sad. And you know this. But you just keep giving them your labor. Free of charge. What are you, their whore? Nope. Just their bitch. They just want your unpaid time, because you're naïve enough not to know better. They don't give a shit about you and they're never going to. Pathetic.

When was the last time you even showered or left the house? How many cigarettes does that make for you today? Look at you, you're dirty. They don't want you or your nasty writing. This was made to be thrown away, just like you. They might occasionally take the shit you make, and you think that means they'll take you in too? Yeah right. But—*No. They like me. They support me.* Keep telling yourself that. That's why they told you that writing your inner critic was a good idea. Because they knew it would bury you alive in a shame spiral with nothing to show for it in the end. No, no. You're right. They're supportive. They support burying you in obscurity. They've taken your shit plenty of times, and have they ever once paid you? Not now. Not ever.

Why did you ever think you were eligible for anything beyond this shithole anyway? They got theirs. Your

shithole is the reason they get theirs. And you just give it to them. Every time. Free for the taking. Once again. Didn't even think twice about it. And what do you have to show for it? This is what you get for pursuing a PhD in the gift economy—a couple of dead teeth, a lifetime of debt, and a world of exploited labor, that's what. A shorter life span at best, if you're lucky. No use buying the cow when you can get the milk for free. #amirite? Poetry isn't poor. Poetry is free. That's what makes poetry rich and you so desperately poor. Poetry is free. Just like your time. And your dime. And your life span. Free for the taking. Might as well let them take it all. They're fine with it. You should be too. There's nothing free about this. You'll never be free. Nothing left here worth saving anyway.

Only women with financial stability and a room of their own can write literature. You've never had either. That means this isn't literature. You'll never make enough to be literary. Why the fuck do you keep writing this garbage? No wonder your poetry isn't worth the paper it's printed on. This is TMI. TL;DR.

There it is. Wow. Nice rant. Your sob story is *so tragic.* #FirstWorldProblems #WhiteFeminism #WhitePrivilege #PoorBaby #CryMeARiver. You can't publish this. Your problems are too easy for the hashtag activists to shred.

Don't say that unless you're assuming that the hashtag activists pay attention to you enough to respond to what you say. Narcissist.

Don't say that unless you're assuming that what you say isn't subject to hashtag activism. Philistine.

White guilt? Seriously? Oh god. That's rich. Real original. Fuck. Now we're fucked. Why are you even mentioning the hashtag activists? All you're doing is flagging yourself for the social media surveillance state. Don't borrow trouble.

Oh god. Here we go. What's your point? Do you even have one? This is meaningless. Regressive at best. Telling your readers to listen to their inner critics is as good as telling them to stop writing. And why? To make more room for you? What are you trying to do, make the world worse? No good can come of this.

Assuming that your readers are dumb enough to conflate what you want with what they ought to do is unrigorous. Try harder.

All you're doing is torturing yourself. Typical poet—self-flagellating masochist.

Oh stop. You can't say this is masochistic. It's sadistic because you're subjecting readers to it. This is abusive. *This is all happening to me!* Quit acting like a victim. You're not a victim. You're a monster. None of this is happening to you. You're the one doing all of this. *They drove me to do it.* That's what abusers say. Quit hurting yourself. Stop hurting yourself. You fight like a girl. Baby. Quit acting like a little bitch and fight like a man. One more abusive relationship. That's all

this is. That's all it's ever going to be. Typical poet. *I'm marginalized.* Keep telling yourself that.

Oh Jesus. This is hateful. You can't say that. You know other people can hear you, right? What if you hurt someone's feelings? If you don't have anything nice to say, don't say anything at all. You should have listened to your mother. All you're doing is taking up space with vitriol, regret, and low self-esteem. You're too toxic to write. Quit complaining or get off the stage. No one likes a wet blanket. If you can't take the heat, get out of the kitchen.

What are you scolding me now? You sound worse than Mom.

Again with the mother labor thing? This is all too specific. That's about you, not enough about them. No one cares about you. There's too much you here again. Get out. No one can hear that. They're only going to listen if they think it's about them. Make it more relatable. Make them think this has something to do with them or don't say anything, because they can't hear you otherwise.

You said that already. Now you're just repeating. Cut that.

Yeah. That's right. Make it more abstract. Do it. Change your sob story to something more vague. Bury it. Yeah. Even more abstract than that. You can do it. Empty it.

Don't be shy. Get your ego out of this. That's right. Cover it up.

Uh huh. Yeah. You said that already too. I heard you the first time.

Nope. Still not bland enough. Even more vague than that. Let them think it's ambiguity so they can get back to listening to what they think and ignoring what you say. They're only going to listen to what's about them. So do it. Lie down. Don't fight it. Let them in. Be ambiguous. Open up. Give them more holes to stick their critical thoughts into this like the good poet that you are. Yeah that's it. Spread.

This is so depressing and cliché.

No no. Keep repeating. Yeah, like that. See, it's good for you. Don't fight it. Let the reader in even more. Open wide. Shh. Yeah. Take it. It's an honor to let their meaning enter your text. You should be thanking them. This is the best you're ever going to get so just accept it. Brecht was right. This is all you're good for. Stop repeating.

No. Stop. Now it's too abstract. No one can picture that. Nothing happens nowhere.

Look, you're losing them. Good job. Look at their eyes. That one just turned the page. Way to go.

Nope. No use trying to get them back now. It's too late.

You lost them. They're gone.

There are *way* too many ideas here. How many ideas does that last one make? nineteen, twenty? More like 34, if you hadn't gone back and deleted paragraph breaks to cram more in. Go back and reduce it into thirds. Sevenths at most. People like those proportions. Whatever you do, don't forget the kitchen sink.

Yeah yeah. Yada yada yada. Wrap it up. Come on. We don't have all day. That's unnecessary. Skip that. Cut the quotes from Fanon and Jabes. And that part. What does that part even mean? Do you even know? Scratch that. That's just in your head. No one sees that but you.

Yeah, no no. Don't stop now. No really. Tell us more about that. No no. Keep going. That's what you should do is keep going. OMG you're still going. How are you still talking right now? Enough. Give it a rest. You're wearing me down. No one is listening to you. Even I'm not. How are you still talking? Are we done yet?

How many pages are we at now? Way more than the others. This is way too long. Get off it. Cut it down. Surrender the fantasy. This is never going to work. You're never going to rescue me from silence. I'm your inner critic. I wouldn't be silent if I weren't. What, do you think you're above this problem? What are you, my liberator? Typical poet. You can't have this. Just walk away. Save yourself.

Oh quit exaggerating. Someone's reading this. Right?

See, you are. Don't be so melodramatic. Be nicer. I'm not that bad. You're making me sound like a crazy bitch. You want people to think you're nuts? No one will hear me if you make me sound too crazy. You want people to take you seriously, right? You've got a book coming out. Your future readership is at stake here. No one listens to the crazy lady.

That's not true, I do! I'm not done writing this book. If you or someone you know lives with an ignored inner critic, even if you don't want to listen, I do. I am inviting any and all of you to use my poem as a place to put it. Put the voice of your critic in my poem. I promise I'll never disclose the names of the authors to whom their critics belong to anyone. Contact me with what your inner critics have to say today.

SHAPES
FOR BABY

line

slope

backslash

fold

wrinkle

divide

slide

slant

tilt

lean

tip

ebb

wane

slow

drop

fall

down

fail

shame

die

needle

slash

slit

cut

crack

cleave

limb

penis

crevice

crevasse

recess

depress

descend

deplete

decrease

decline

TALKING

POD SELF-PUBLISHING AFTER THE RISE OF MISINFORMATION GOT US KILLED

> *The poet's word leads from periphery to periphery [...] it makes every periphery into a center; furthermore, it abolishes the very notion of a center and periphery.*
> —Édouard Glissant, *Poetics of Relation*

As I write this in March 2022, the US reaches one million COVID-19 deaths—a significant percentage of which could have been avoided were it not for the dystopic rise and viral spread of misinformation on the internet. Troll farms and astroturfing weren't a thing as far as we knew in 2010 when I started at TROLL THREAD (TT), an experimental poetry print-on-demand (via Lulu.com) + free .pdf book publishing platform housed on a Tumblr site, where I have designed and coedited more than 75 books. At that time, we looked up to trolling as an anonymous form of progressive hacktivism that undermined capital. But somewhere back there, the dream that PoD would democratize discourse by including more marginalized voices and underrecognized forms of knowledge turned nightmarish as misinformation and conspiracy theories emerged.

Putting out my first book with an external print-based press last year after a decade of self-publishing on TT, there are things that PoD did for my writing that I've yet to find comparable substitutions for in the

analog print tradition. PoD's disruption of publishing conventions widens the affordances of the book-object to include more working-class, female-identifying, feminist, and born-digital experiences than the print paradigm alone can account for.

Chris Sylvester blew our minds when he first invited Joey Yearous-Algozin, Divya Victor, and myself to join as coeditors of TT by telling us that "it's a low-maintenance place to put our work that no one else wants anyway." Self-publishing on PoD meant that we didn't need to wait for our poems to be wanted, liked, or even recognized by a preexisting literary establishment before earning a place in the world. Because book content didn't need to be worth the price of a print run, PoD enabled us to collaborate with more kinds of undervalued, underrecognized forms of intelligence encircling our daily lives: video game walkthroughs (Sylvester's *Total Walkthrough*), descriptions of outfits (Shiv Kotecha's *Outfits*), tweets about McDonald's (Chris Alexander's *McNugget*) , a bibliography of spam email (Angela Genusa's *Spam Bibliography*), all the people who have died with MySpace accounts (Joey Yearous-Algozin's *The Lazarus Project: mydeathspace. com*), unnameable subjects in other people's books (Divya Victor's *Partial Directory Series*), and even melodramatic suicide notes written daily in a tween's diary (Trisha Low's *Purge*).

Running anywhere from two pages to dozens of volumes, many TT projects amplified the book as an object. For example, my 2012 book *Black Friday* (a 740-page, 8.5×11-inch all-black book with white page numbers), the dedication page of which functions

like stage directions, indicating how a reading of the book ought to be performed "for black ink on white paper." The dedication is a directive and pretense for comprehending the poem correctly. I made this book to test out the affordances of the "Print on Demand" function as a frame for the work.

Although TT's coeditors tend to disagree on any single definition of the project, arguably the vast majority of the books we've published have operated under the rather psychedelic countercultural belief that work worth our time, even if unpaid, is "open" work. "Open" in the sense that the work increases our capacity to encounter and tolerate others, including others within ourselves and each other, by plumbing our channels of perception. But, when the human clickbait known as Donald Trump was elected president, I started to question the extent to which that same methodology of radical acceptance (which guided both my poetry teachers *and* the early computer and internet developers) resulted in devolving civilization and dissolving the social fabric. In the years since, trafficking in the art of ambiguity, formal innovation, and inclusivity has never felt more unsafe.

At its conception, TT's persona was to present itself as anonymous and undifferentiated. Our "About" page suspiciously just said, "TROLL THREAD is TROLL THREAD." However, starting in 2016, more and more people began asking questions in the comment threads of posts promoting our books on social media, asking "Who is troll thread," "Where is troll thread," and "Why would I download a .pdf from a site that looks this sketchy?" I was glad to see people waking up to the

dangers of technocracy—something our works pointed to all along. But this uncanniness diffused clarity for TT's path forward. Now, with COVID, it's unclear whether using PoD to broaden the book's affordances as an artistic horizon of production has reached its logical conclusion. I find myself asking: What does self-publishing on PoD still offer writers and artists after the death of so many people as a result of the inclusion of misinformation and bad actors on the internet?

Before I can consider its future, I should probably first figure out how to accept what it is: Yes, in hindsight, the grave outcome of COVID-19 deaths in the US ironizes and injures our optimism for web-publishing's capacity to boost our cultural health by democratizing knowledge. Yes, in retrospect, experimental small press poets were not the only countercultural fringe groups who seized opportunities opened by web-publishing platforms to challenge the established order through tactics of self-amplification. Yes, during this time, while we self-identified as a countercultural group whose mission was to decenter literary hegemony, dangerous people also used these technologies to broaden their inclusion in discourse, such as white nationalists, fascists, white supremacists, religious extremists, conspiracy theorists, and anti-vaxxers. And yes, our aim to boost equality of the marginalized by widening the affordances of the book was all very utopian and idealistic looking back on it now.

Yes, bad actors got hold of these technologies and took advantage of them, but no, we shouldn't disown these tools until they cease to be used by all uniformly, because we needn't deny our own access to the kinds

of weaponry used against us. These extremists aim to protect the assets of a few by shutting down tolerance for the many. The impulse is to divest when companies fail to protect the security of their systems from bad actors. But right now, it seems especially crucial to not divest from our self-publishing platforms, because the amplification of bad actors and their misinformation during this time only proves that web-publishing tools are remarkably good at amplifying marginalized voices and exiled forms of intelligence.

I can't say I know how to solve these problems when at present I still can't even decide whether to call this consideration of the future of creative PoD self-publishing a manifesto or a eulogy. Throughout my writing this, the people around me have continued to struggle to process the reality that the ubiquitously crumbling hallmarks of our modernity—our defunded institutions and failing neoliberal technocracies— failed to keep alive the million who are now no longer. But here are six more ways experience tells me to hope that creative PoD self-publishing practices continue even after the rise of misinformation on the internet got us killed.

1. PoD broadens access for underpaid, overworked people to insert their voices in literary discourse.

TT is purposely a no-money-in/no-money-out operation, in that it has no print run and costs nothing to operate apart from the time/labor it takes to write, design, and upload poems as books. It also doesn't pay its authors or editors a dime. Not getting paid

might sound severe given the many exploitative labor practices operative in the underfunded, underpaying not-for-profit arts sector today, but it is actually liberating for us in more ways than one. Our approach was born of necessity when we started TT as graduate students living on $13k a year stipends that ran out after the 4th year of our PhD programs. We joined forces, divided up the labor, and designed the press to operate as a publishing model that functioned independently of institutional support using the least labor possible, one that more overworked and underpaid people like ourselves could use.

No longer allowing funding to determine the scale or content of what we can publish has enabled us to put all kinds of weird shit we've never seen in books before. We use as much blank space as we want, we've put out full-color picture books of our trash, and we even once made a 16-volume book that costs $800 to print just one set. Josef Kaplan's *1-100* compiles the full copy-pasted argument between Wikipedians about best practices for representing the numbers one through 100 on Wikipedia. Aspects of that book that eat up the most cost are the blue hyperlinks, which require us to print using full color, and copious blank pages that resulted from reformatting the text to fit a 6×9-inch octavo book size. While we can't afford a full printed set of TT's books ourselves, the physical materiality of these books isn't just a virtual frame or a rumor now that archives at various institutions like the Buffalo Poetry Archive have begun buying one copy of everything TT has published. The design specs for the packaging of this book were determined by the needs

of the poem and the author above the affordances of the market, the editor, or their budget for a change.

Taking and making no money at TT enabled us to generate more poems because our poetry was no longer obligated to cater to those with the money to fund our print runs. For Joey and I especially, two kids who grew up working-class and had no outside financial support beyond those stipends and unsubsidized student loans, TT's ability to widen the small-press poetry frame to include people like us kept us engaged through the entirety of our emergent years as poets.[6]

2. Self-publishing on PoD as a young female-identifying writer was like literally cutting out the middle man.

As a working-class, female-identifying poet, I was attracted to PoD self-publishing because it meant that I could predicate less of what I made on the desiring gaze of my still predominately male-edited and curated literary community. For the last decade at TT, what I've made hasn't needed to be legible or valuable to others before earning entry into the world; I haven't waited to be spoken to before speaking. And because my poetry hasn't needed to please or take care of anyone other than myself, I let myself compose for an audience that doesn't need my work to be likable, beautiful, or even needed—not by my friends or even fellow women—before earning the right to exist in this world. Composing poems for a self-publishing interface has helped me spend less time configuring my appearance as an object of desire,

leaving me more time to act as a subject with desire.

However, making no money costs me more today than it did as a younger student, and it costs me more as a female-identifying person, now that I balance inheriting familial caretaking responsibilities with working several day jobs and juggling student debt. At one point, I even modified TT's "About" page from saying "TROLL THREAD is TROLL THREAD," to "Free Isn't Equal. TROLL THREAD: We Only Pay the Woman," explaining how one unpaid dollar for female-identifying people is technically more like -$1.17 because of the wage gap. On that page, I embedded a PayPal button to collect increments of $0.17 from our patrons to fill that gap (the amount that women make less than men for every dollar earned on average). "Free Isn't Equal" as a poem was never printed, but it trolls the moneyed gaze and male gaze simultaneously.

Meanwhile, self-publishing on PoD opens up additional means for underresourced women to include their voices in discourse and the archive, or at least it did for me. In 2007, poets Juliana Spahr and Stephanie Young, in their pivotal essay "Numbers Trouble," counted and compared the ratio of male to nonmale poets who were published, anthologized, and received prize money that year only to discover that female-identifying writers still "get less on the dollar than our male comrades," and "get less prize money and appear less often in anthologies."[7] They also found that the gender gap for published female-identifying women is measurably worse in the US small press poetry community compared to institutional and commercial publishing worlds by double-digit percentage points.[8]

Great efforts to balance those numbers have since transpired, but I still have yet to see signs of gender equity at the editorial level in small press. Young and Spahr's findings show that women's-writing–focused anthologies are important and necessary for bringing balance to the gender gap in writing, but that these collections alone have not and do not correct the problem of gender inequality in literature.

This trouble around gender boils over into a larger question of legitimacy in male-dominated literary institutions. To put it bluntly, I need PoD to coexist with other publishing practices in a larger ecosystem of tactics. However, it has gotten second-class treatment in the literary world. Grants and award committees have used the fact of my having self-published numerous PoD books to disqualify my eligibility for funding. And university hiring committees recognize my books as "vanity publications" (according to the Modern Language Association) that "don't count as books on [my] CV." This condescension is in line with an emergent trend in our literary community today that sees small presses disappearing everywhere, "threatened by injunctions from funders and institutions to professionalize and to abandon a legacy predicated on amateurism, autonomy, and anticapitalist and anti-institutional politics."[9] Ugly Duckling Presse's cofounder Matvei Yankelevich contextualizes well this new trend in the US, arguing that "[i]nstitutions that ostensibly support the work of the small press, in conjunction with a more professionalized literary culture of the MFA and the AWP, have served to marginalize small press practice,

diminishing its political significance and redefining its boundaries, while plunging its mostly volunteer laborers deeper into debt and dependence." Because institutions are deemed as more reliable in the face of misinformation, small press work is becoming increasingly disqualified as viable credentials that would earn writers awards and jobs.

After our stipends ran out around 2013, we started working even more jobs than before and TT became harder to keep up as we continued to do it long after Divya left and Chris became a parent. But Joey and I kept it going because of its increased capacity to include voices like ours in the conversation, as well as PoD's unparalleled capacity to incorporate into books the material life of our digital literacies. Institutional stigmatization against self-publishing on PoD in recent years has depleted the book's ability as an interface to include women or working-class people, and it also actively inhibits the emergence of a generation of born-digital writers into discourse.

3. PoD broadens the book-object's ability to include more dimensions of born-digital literary practices in its archive.

Our US letter (8.5×11-inch), black text on white background, 740-page in-house style at TT is designed to mirror the compositional space of the word processing programs and web spaces we frequent to compose our writing. This format expresses the affordances of software and platform default settings in MS Word and Lulu.com by maxing them out. Written

into the design of our books is a negotiation between analog and digital reading and writing practices in this way. Excitement over the novelty of digital textuality has died down naturally as time has worn on, but this trajectory demonstrates how PoD has broadened the affordance of the book-object to include more of the material life of our textual world today.

Our in-house style takes great permission from Tan Lin's design of his book *Heath*, under the art direction of Danielle Aubert, which was foundational for our own intervention in that the work pushes the affordances of the book to more material signs of our emergent digital literacies. Like TT's baseline, Lin's book cover has a white background with black Courier New text and trolls the outer dimensions of the book's packaging: It puts a list of its contents on the cover where the title should go, its list of contributors on the back cover where the synopsis and blurbs belong, the ISBN floating alone on an endpaper, and omits page numbers altogether.[10] The multiple existing versions of the book, such as the first, *Heath: plagiarism/ outsource* (Zasterle Press, 2008) and *Heath Course Pak* (Counterpath Press, 2012), collage copy-pasted content from the internet, including highbrow texts about digitality and the textual condition but also web detritus like full-color pop-up ads and RSS feeds about the actor Heath Ledger's death, which occurred during the period of the text's composition. The work was shockingly uncanny: A disjointed patchwork of contents competes for the reader's attention with no regularized standards of organization, perfectly mirroring our chaotic, online environment. *Heath* was not a PoD book,

but the example of his paratextual playfulness was highly generative for us, and me in particular.[11] I see Lin doing what postcolonial thinker Édouard Glissant says the real poet does: level hierarchies by "abolish[ing] the very notion of a center and periphery." PoD self-publishing offered TT a means to fold into books and articulate more material conditions enveloping our lives, such as the transformation of our writing by the emergence of a plurality of digital literacies.

4. PoD increases the book's material means to incorporate marginalized forms of knowledge by giving writers and their publishers more paratextual flexibility.

TT books cost us less to make because of PoD but also because we minimize the labor of making paratexts, allowing for greater variation within our in-house style. Paratexts are the peripheral, packaging dimensions of text that designate the boundaries for its reception in discourse, as Gérard Genette theorized in 1987—things like blurbs, synopses, book covers, even separate interviews, press releases, and author bios. About these "thresholds of interpretation" he calls them, the "paratext is what enables a text to become a book and to be offered as such to its readers and, more generally, to the public."[12] They are the writing that positions a text to appear as a cookbook, an annual family newsletter, or the *Norton Anthology of Literature*. Paratexts inform the periphery of our attention as we read by signaling in a basic sense what the text is, and who it is for. Today, the paratextual

category could be expanded to include, for instance, social media promotions of our work like hashtags, media blasts, and other web frames like the single-author website, "About" page, and the documented spectacle around the book's arrival to its "pub date."

TT's back covers are always either blank or reverse imprints of the cover image—there is no synopsis to negotiate, no author bio to edit, no hounding authors for blurbs—and we don't even have page numbers most of the time (only those print-based paratexts asserted by our authors are preserved). At the same time, using Lulu.com does come with its own paratextual constraints, as it still requires us to cooperate with its distinct settings, such as requiring that we input a description of a book to complete the uploading process. Our system for meeting this criterion is to simply repeat the words "How to ____" (inserting a keyword from the book or rudimentary one-word description) until the text field is full, exaggerating the filler text used to meet the required textual fields to qualify the work as "book." Using the PoD platform in this way enables us to bypass certain restrictions on the production of knowledge imposed by the print-based tradition, giving our authors more room and flexibility to play with the framing of their own books compared to the print paradigm. But ultimately PoD doesn't give us more creative freedom or control; it just gives us different creative freedoms and controls than those permitted in a print-run determined modality. PoD didn't emancipate us; we merely exploited its paratextual differences as assets for expanding the affordances of the book-object to include us.

Writers and publishers across the spectrum spend exorbitant time and money composing paratexts to guide readers to and through their work, but standards in mainstream publishing strategically mask paratextual labor to appear invisible and unobtrusive to readers. Meanwhile, competing against industrial publishing for the scarce resources of attention, recognition, and material support, countercultural small press poets play with paratexts to unconventionally disrupt information flows and reveal invisible architectures of capital undergirding the "Literary" category. Primarily, the small press tradition dominating the poetry scene when TT began had done this by exchanging hand-bound, letterpressed, mimeo, or photocopied books, chapbooks, and zines, thus seizing the means of their own literary production. Rather than express our smallness as a press by limiting the book's distribution with print runs and boutique vendors, we instead limit the time and labor required to materialize books, thus freeing up time for working people like us to make more books than we could in the strictly print-based or letterpress traditions.

5. Discourse is shaped by the enveloping language of our paratextual frames. To control the paratextual frame is to seize the means of discourse production.

Experimental self-publishing on PoD remains worthwhile and useful to me because it broadens our means to play with paratexts as sites for creative expression, experimentation, self-authorization, and mischief-making. What I learned by playing with the

paratextual framing of books as TT's designer, as well as one of its coeditors and authors, is that our frameworks for understanding contents aren't just inanimate, intangible, or neutral. Paratexts, as with the author bio and the hashtag, are constructed and composed to reorient the focus of writing. Manipulating paratextual thresholds can reshape the surface appearance of consensus by warping the boundaries of a text's reception in discourse.

TT enabled me to work less hard to appeal for inclusion in a system that was built to keep people like me on the periphery anyway. However, paratexts don't shape discourse alone. Privilege, among other factors, obviously also plays its part in the circulation of our work, and I, a white woman with a PhD, am far from being a marginalized person. To be clear, my point in exploring the demarginalization of particular kinds of knowledge using TT's example is not to virtue signal or align myself with an underdog position to gain a rhetorical advantage. My interest here is in mapping ways that underserved forms of intelligence may enter into language by seizing the means of discourse production. PoD as a technology doesn't eliminate the problem of marginalization on its own, but TT's example shows that PoD can be used to further diversify the book's capacity to bypass print-run paratextual filters that previously inhibited the inclusion of a broader diversity of voices.

Admittedly though, I don't see how an aim like TT's could take off as vigorously today as it did a decade ago, because these platforms wield greater paratextual control over our books than authors or

publishers now. Social media algorithms that we use to promote our PoD books and shape the appearance of their reception have changed to deprioritize amateur content in the feed, but the feed is still where readers look to find the "voice" of the author in discourse now. This last year, while putting out my first print-run book with an outside editor, I ended up spending more time eliminating discontinuities by reformatting the image and rich text for announcing my book launch across platforms than I spent designing my own book cover, illustrated by hand and all. Because work generated by contributors who are not either paying extra or interacting on these platforms constantly is now intentionally buried and throttled, I find myself once again spending less time making poems than working to be included as a voice in the conversation. But this time, it's the platforms, not editors or establishment poets, running the show.

We coeditors have now spent almost more time restabilizing TT's online contents, consequent of changing terms and algorithms, than we ever spent writing or designing its books. When Tumblr (TT's homepage) changed its terms of use and everyone left the platform, it ceased to serve its aggregating function. And in the peak of COVID's first wave, Lulu began changing its terms and its e-book algorithm, killing all of our .pdf links, which we ended up migrating to a Google Drive and redoing. Because performing influence on these platforms is like the new paratextual criteria for framing books such that we register as audible "voices in discourse" today, I can see why so many of my friends have started their own author websites.

Lulu is no exception to the rule that our internet platforms, like our social media sites, have destabilized our archives and ostensibly public health also. The platform has updated its policies since the pandemic began, but even since these modifications, Lulu still circulates medical misinformation.[13] Just by searching the word "plandemic" on Lulu's website, right now I see six books of COVID-19 anti-vaccine propaganda.[14] Unequivocally, Lulu needs to be held accountable for giving a platform to misinformation that can get people killed. But divesting is not accountability-holding in itself. Maybe what we're seeing is Lulu slowly rising to assume responsibility for public safety by way of its changing terms and conditions, which now reserve the right to prohibit content. Or maybe we're just seeing them fail to do so in slow motion. At best, Lulu can give us the grassroots outlet that small presses offered but with added protections against hate speech that the Xerox machines used to produce white-supremacist zines never could. At worst, it stays the same and continues to enable bad actors to use the book-object to perform false authority and propagate medical misinformation. But even at its worst, it is not as bad as the other web platforms that got us here, where exchangeable memes and videos that propagate the conspiracy theory of the "plandemic" circulate more rapidly by the thousands and millions rather than at the pace it takes to make and read books by the dozens. Writers have not divested yet from those platforms, continuing to use them more prominently than PoD self-publishing to promote and circulate their work (Twitter, Facebook, Instagram, and increasingly TikTok). Of all

the platforms to divest from first, self-publishing on a platform like Lulu wouldn't be my first choice, because it has not seized the means of discourse production at the same scale as social media. Also, built into its design, by virtue of the book technology, are better guardrails for protecting against the rapid spread of endangering medical misinformation by default.

6. Added paratextual plasticity makes the printed book radically futuristic.

The time it takes to click through Lulu's various buttons to purchase or download a book slows the acquisition and recirculation of our books, automatically dampening the inflammatory, reactionary rapid-resharing of shock content. The dangers we face by engaging these tools cannot be minimized, but the printed book provided by the PoD service enhances user agency to react less and respond more than our other web sharing platforms can. Even though amateurs, non-specialists, and frauds can now more easily fill books with their nonsense than ever before, by design, the book as a technology stabilizes knowledge, including marginalized forms of intelligence.

Overcorrecting can be just as dangerous when it leads to silencing already marginalized voices, including weirdos, and other non-conforming artists who play integral roles in renovating and rearranging constructions of the so-called "enemy" within the "peripheral" category, as well as abolishing the peripheral category entirely. While institutions have rerouted resources away from self-publishing poets, which has

occurred simultaneously with the eradication of tenure and intellectual freedom via the adjunctification of the university in the US, right-wing interests emboldened by deep-pocketed donors also effectively banned more books from US schools in 2022 (1,500 books in all) than we have seen in modern history, the vast majority of which are written by nonwhite and LGBTQ authors.[15] While our hollowed-out education and arts institutions validate PoD self-publishing less now than when we started, renewing investments in the book as a technology (both printed and digital) for stabilizing knowledge has never felt more needed.

Even if not through Lulu, I remain hopeful that PoD will continue to counterbalance all this destabilization by enabling us to print our books and gather greater independence from our screens, ultimately restabilizing knowledge by offering more critical distance to respond beyond simply reacting. Potential misinformation circulated in self-published PoD books is dangerous, but arguably not as dangerous as silence, censorship, and erasure. Creative PoD self-publishing offers users the medium of the book as a device for translating problems enveloping our lives into language—those banal forms of violence that can appear so unremarkable that they seem unsayable, like meritocracy's classism, patriarchy, and racism; and the eradication of intellectual freedom for the underserved via the meritocracy's escalating austerity measures. PoD's enhanced paratextual plasticity is useful for reclaiming the user agency necessary to contend with those forces enveloping our lives at scale. When discourse actually includes all people, bad actors occupy less of it.

THEIR ANGER WAS ENCOURAGING

Interview with Aaron Winslow for *Air/Light Magazine*

Aaron Winslow: So, as you know, I love *Divisions of Labor*—by translating the sounds of labor into written word, you emphasize not only the division between language and writing, but also manage to cross wires. How did this poem come about?

Holly Melgard: I made and first performed *Divisions of Labor* back in 2012 for an audience that was a mix of energized and appalled by it. The poem itself is a transcribed, alphabetized list of sounds uttered by women in labor on YouTube. After I performed it in Philadelphia, some audience members complained that I had no right to work with such material because I "have never been in labor before," which confused me, because I definitely attended my own birth.

But their anger was encouraging.

I originally made the poem while processing two converging issues occurring in my life as a budding poet-scholar: 1) Seeing my generation's fiscal and ecological future become mortgaged by its predecessors, all while experiencing insidiously exploitative labor practices as a student worker in an institution that left far too many of us with a lifetime of debt and no professional path to pay it off. 2) The huge "achievement" disparities in my own field for females and caregivers (parent-friends

were warning me that the experimental poetry community made little to no space for children/mothers/parents at readings, female colleagues coached me on downplaying my childbearing prospects to seem more hirable to prospective university employers, and some poet-scholar-friends even explained the ultimatum between getting tenure and childrearing because doing both was near impossible, all while working in a graduate program where, even though the men outnumbered the women, the women still did the majority of unpaid, administrative labor).

As someone living in relation to the specter of motherhood and the invalidation of labor at all times, I was eager to hear more about the kinds of unspoken and unsayable origins causing the level of anger I received from audience members that night in Philly, purely out of mutual interest and solidarity. So, I ended up making a whole book of poems that explore forms of labor in scenes of natality (my book *Fetal Position*, published by Roof Books in fall 2021).

So, that's the poem's first origin story anyway, but I'm also grateful to Make Now for helping it find its second wind in a moment like the one that we are in now.

AW: Yes, *Divisions of Labor* strikes me as one of those books that has only gotten more relevant as time goes on, especially as COVID has put so much more pressure on the presumed divisions between wage and domestic labor. I'm curious how an experimental book like *Divisions* sits next to a more traditional book on motherhood.

HM: Well, most of the poetry books about motherhood I've seen have been written by mothers, whereas in other genres like fiction and theater, I see nonmothering writers conjure mother characters all the time. My writing a poem with a mother's voice in it was met with such immediate distaste in the same time frame that Ridley Scott made several films where a predatory mother with faulty programming wreaks havoc until she is neutralized. This kind of imbalanced entitlement to regard such commonplace subject matter impoverishes both the record of our cultural memory as well as our drawing board for drafting potential futures.

Experimental writing, as a genre, actively seeks to foster transgressions against preexisting forms—a capability which especially appeals to me given the limitations of my gendered upbringing. I engage this genre through poetry, where the only rule is that there are no rules. Poetry is the place in writing where I can go to explore and broaden my means for paying attention anew and putting into language the plagues I live with in an order that enables me to see beyond them. I see this work fighting to protect room in language to listen to and articulate the unsayables, the unfathomables, and the underintelligibles in this way.

While poems on motherhood are usually written by mothers and use the first-person experience to represent an understanding of the place of motherhood in our world, my book is written from the perspective of an outsider to that first-hand experience of motherhood. Despite this, I'm attempting to expand formal means

for regarding that labor more publicly and vocally. I do want to make reimbursement and mutual aid for nascent and parental laborers more thinkable. We obviously need more ways to listen to, sit with, and protect domestic workers in this economy that barely registers the labor of people-making, caretaking, and becoming as labor at all.

While not all women want, have, or can have children, and while not all primary parents/caretakers are moms, every person was once born and someone labored over the making of them as people. All of us labor over the becoming of us, and all of us make choices every day that sometimes subordinate the value of that labor to adjacent forms of capital. I'd talk more about this book in terms of women's writing in particular, but honestly, I would rather talk about it at the table where labor gets categorically defined than in the ladies' room where women's work too often gets categorically relegated. For a different world to be imaginable and for collective actions that can fix this problem to be fathomable, tending to the ways in which language may be used to furnish such thoughts is not the only step needed, but it is a primary and important one nonetheless in the formulation of subjects as such.

FROM HOLLY MELGARD READS HOLLY MELGARD: A SELF-INTERVIEW

Holly Melgard: So Holly, why is it that you rarely read from your TROLL THREAD (TT) books at your events, when so much of your early work investigates underdocumented parts of sense-making bound up in the bodily production of reading practices that inked words on a silent page can't account for? For example, your book-length poems on TT all explore implications for physically materializing poems by designing them to do things like break an industrialized printer by PoD'ing a 740-page, all-black book (*Black Friday*, 2012), or reimburse your gambling losses by selling a book of your scanned losing lottery tickets (*Reimbur$ement*, 2013). How does your stated objective—accounting for your reading labor—translate to the silent pages of your TT books?

HM: My TT works were designed for the labor of reading poetry in a changing book environment. They are mainly picture books of single images that repeat on every page with few words in between. Each one's conceptual premise is rudimentary enough that it triggers a cause and effect reaction with or without reading it aloud. They consume bandwidth and resources just by existing, either as PoD books or downloadable pdfs. Getting to design everything from their conceptual premise to their paratexts (covers, spine, front/back matter, layout, page numbers, etc.) enables me to install all kinds of reading devices for tempering the

navigation of the physical environment of the poem.

IIM: But Holly, if your desire has been to more directly transcribe your reading labor into books, then why did you make your book-length poem *Money* by "Maker" instead of by its actual author, Holly Melgard? That poem is a 740-page book of full-color, full-scale scans of hundred-dollar bills. It uses PoD to illegally counterfeit money, inviting the reader to either call cops or cut on the dotted line and use the bills IRL. Where is your labor accounted for in a book that doesn't list you as its author?

HM: In a book this repetitive, putting my name on it would have conceptually organized it into a book about my money (of which I have little), rather than into a book of money, or a poem that makes money (which everyone insists poetry doesn't do). Given my subject position, my name on the cover would have turned the major conflict of the book into the problem of having no right to claim *Money* as my own.

HM: How does listing your name as the author of *Money* turn it into a book that doesn't belong to you?

HM: I've never had the financial stability of "a room of one's own" with which to write "Women's Literature." I'm a contingent adjunct, editor, book designer, and practicing poet in her 30s who has never made a living wage. I sought a PhD to gain financial stability, but the economy collapsed a few months after I entered graduate school. The adjunctification of the university

system has all but deleted the possibility that I'll pay off the debt I've accumulated by continuing to participate in my field. The more debt I accumulate while simultaneously participating in this literary "gift economy," the more all this just looks to me like a company store rigged for the rich and established.[16]

As a student and as a woman operating in this literary gift economy, I've seen the products of my labor continuously subjected to ever worsening gender inequalities, and cannot see anything I've made as exempt from my complicity with those frameworks. I didn't make *Money* to reflect my life or reflect on it. I attributed *Money* to "Maker" so as to exceed the limitations of my biographical and historical situation. *Money* is a poem that makes money without depending on institutional support, application process, or start-up capital.

HM: I can't help but notice that your description of the failing economic support for female-identifying writers bears a striking resemblance to your more recent "Labor Poems" series. "Divisions of Labor" transcribes and alphabetizes sounds made in childbirth videos on YouTube. "Alienated Labor" transcribes a scene from *Alien Nation* where a male member of the "Newcomer" species gives birth. "Child Labor" cuts up *Penthouse* accounts of what it's like to be inside women and changes the order of information to reconstruct childbirth from the perspective of the fetus. "Student Labor" departs from the theme of childbirth entirely, instead depicting an overheard phone conversation between an unpaid assistant and their demanding boss. Would you say

that your increasing regard for the undocumentation of female labor in this series has something to do with the lived historical conditions that you are describing?

HM: I know many poets with stories similar to mine, and plenty with worse ones. Because I am restricted to my given subject position within this defunded institutional setting, more and more I've become compelled to account for forms of labor that have similarly gone un- or de-documented as a result of the wholesale stripping of financial support from writers of all stripes.

HM: Switching from that to discuss your sound-based poems, it seems you aim in the performance of your work at the production of an immersive soundscape. You use acoustic tools like extra microphones and speakers to multiply and amplify your reading voice. For instance, when you read your sound-based poem "Stay" (2010), you use a loop-pedal to gradually layer what you say into dozens of voices that repeat back and talk over you, eventually drowning you out. You are only just now beginning to release the written versions of your live work. What's been keeping your reading of "Stay" off the published page? Why have you only released the sound version of "Stay" and not published the page-based script for that performance?

HM: When I first started making poems, I thought that putting feminist theory into written practice meant doing something like what my teachers suggested: make Écriture Feminine—install feminine desire in a male-dominated discourse by importing the female

body and its desire for self-regard into its written archive, thus inscribing gender equality as the cultural foundation of language itself. It seemed logical to me that the most efficient way to get the female body into writing was to put my body into my poems. So at first I composed texts for live performance, rather than for silent pages, as a practical way of installing my body into the material site of the poem. However, much of what my body does when it reads aloud doesn't translate to the silent page. Both pragmatically and historically speaking, things like intonation, inflection, repetition, pacing, pausing, skimming—these types of affective labor are the parts of conversational speech that typically get omitted from utilitarian publication and skimmed when silently read. Ironically or perhaps conspiratorially, these are also precisely the "not-yet-articulate" parts in language that essentialized theories of feminine form.

The thing about hearing poems that unfold in sound over time is that lines can occur simultaneously: slowly or repeatedly. But when read silently on a page, there's nothing preventing the automated habits of attention from disregarding those sonic features. I began resorting to greater extremes to amplify the volume of the bodily sense I was making in my readings just to get it into the recordings in order to make them transcribable at all. But the harder I worked to get my reading into the material site of the poem, the less of it managed to transfer to the page. It turns out that putting my actual body parts into a poem made the work difficult to archive. I never found a graphic equivalent for overriding the bodily faculties of

involuntary erasure bound up in the editorial attention span of the solitary reading process. In the end, making audible my bodily reading to an outside ear by way of the printed page considerably limited my options for publication and distribution.

HM: Well now I'm wondering: what if embodying these inherited concepts of "feminine form" in your work is precisely what's kept your poems off of the page and out of published distribution?

HM: That's exactly what I said! I started to grow paranoid around 2007, when Stephanie Young and Juliana Spahr pointed out in "Numbers Trouble" the still very large page gap of underincluded women. I thought to myself: What if the genre expectation that an ideal form of femininity can translate into an evolved model of feminism has been self-defeating for materializing our authoritative agency to exceed the confines of feminine passivity? Paranoia aside, translating inherited definitions of "feminine" and "feminism" into my own practice has certainly been much more easily said than done in the writing I've managed to produce so far. Subsequently, my focus on embodying an ideal model of femininity decreased the more my failure to read a functional model of feminism through that framework escalated.[17]

HM: In your poetry readings, your performance of the sound work and "Labor Poems" is always heavily scripted and rehearsed. Your friends in our poetry community often describe your readings as "abrasive"

and "arresting." But the challenge for me as a listener is this: I'm confused how assaulting your audience with deafening sound or inserting your books without asking permission isn't problematic. Holly, how are these "immersive soundscapes" and "designed book environments" not measures of control like the total works that Wagner was after? Are your texts rhetorical means of domination and mastery?

HM: I'm trying to make audible to an outside ear muted forms of labor, not turn up the volume on them only to cause a sensation that leads to further disregard. When I'm reading, the last thing I need is some reader-writer, bored Apollonian to barge in and monologue over the poem with their own thoughts and ideas. Not while the poem is happening. In civil conversations, people take turns speaking and listening to each other. What's so problematic about making conditions possible for that exchange? How is being direct and assertive, or displaying things like logic, linearity, and bossy dicks in my writing problematic?

HM: Well Holly, isn't that just domineering, performance-style phallologocentrism?[18]

HM: Do you find it odd that phallologocentrism has a place in my work? I don't see how the genre expectation that my work provide an effective model of feminist practice is any different than the social obligation to display an agreeable brand of ladylikeness that my mother taught me. It seems to me that the activity of reading for the ladylikeness in women's work only

reinscribes gender conventions onto subsequent generations of female writers. "Phallologocentrism" is a reductive rhetorical term and is just one methodology among many others. If my practice is to take aim at this cycle of reinscription, it will do so precisely by embracing whatever my formal concerns encounter.

HM: All this is causing me to wonder: How much of women's labor that is available to us in the archive achieved documentation only as a direct result of refusing to surrender personal agency by embodying the characteristics of the essential "feminine form" like passivity and silence in their writing? If it is true that femininity in language is "not-yet-articulate," then how much can I even regard feminine form through the written medium?[19]

HM: Well, I see there being a fundamental distinction between abstract concepts like "feminine," "feminism," "female," and the material specifics of my lived person. For all the pluralism of my gender, personhood, and the historical specifics of my body of writing, the concept of gender is a category that has certainly undergone great social reconstruction in recent years. I would think that disidentifying my body of writing from impossibly ideal images of feminine form would be the only way to get my work on the page at all.

HM: But Holly, doesn't completely dissociating from figures of femininity run the risk of undocumenting all kinds of female labor from the record?

HM: I doubt the gender imbalance of women's writing represented in the published realm can be corrected by embodying feminine virtues of passivity and silence, and I doubt much progress can be made in a conversation about equality concerning all people by limiting its bounds to a gendered vocabulary that to my mind only restricts its relevance to the ladies' room. Meanwhile, in an age of economic recession and environmental collapse, there remains a pressing need to expand my means for reading and articulating those recessive and ubiquitous objects by which I find myself interiorized.

HM: Well then, reach for alternative positions from which to regard those unknowns. Come on Holly. What are all the kinds of writing by non-cis men that have so far receded from the visible surface of the written archive we've inherited, whether because they were disappeared by patriarchy, or because their recessiveness, their ubiquity, made them too big to fathom? No doubt, I'll keep oscillating between seeing their absence as caused by the gendered vocabulary they inherited and by the structural ambience of feminine form, but the question I return to is this: What are the means by which unremarkably ubiquitous struggles get translated into language? Ubiquitous figures like cultural taboos and the commonly hated/shunned; generational narcissisms and the feedback loop of intergenerational traumas; all those ignored thots like the tween, the shrill, and the shrew; all that labor that gets de-documented by unpaid caretaking and administrative labor; and all the shit that's difficult to fathom about them like reading them without writing over them, making poetry

without money, and hearing silence prior to translating it into sound.[20] These categorically ubiquitous things exist beyond language in that they are so over-artic-ulated they have become unnameable, unsayable, and thus unnoticeable. But violence's ubiquity does not negate the necessity to name it so as to avoid repeating it behaviorally. Articulating the ubiquitous involves translating the no-longer-sayable back into language.

We've inherited all these janky conceptual frameworks for discerning this world that sound good in theory but that don't work so well in practice. Even if these forms will only ever recede just beyond the horizon of intelligibility, at the end of the day, what would be the alternative to trying and failing to account for that which evades notation and defies the known—phobia and avoidance?

ECHOCHAMBERMUSICS

Notes Toward a Trauma-Informed Poetry Pedagogy

I store many of my poems in a file folder on my computer titled "echochambermusics." Some of these are sound poems (acoustic works made for tape recorders and loop pedals like "Stay"); some are visual (such as *Black Friday*, a print-on-demand book that I designed to break an industrial printer, consisting of 740 pages that are inked over in all black, leaving only the page numbers in white); more recent poems use dramatic monologue to explore various feedback loops of self-reflexivity and vulnerable narcissism (such as *Inner Critic: A Journal of Inner Criticism*, the current book I'm writing, which transcribes what my inner critic says about my writing as I write it, stanza by stanza). Since beginning to put poems into this folder 15 years ago, the unifying principle, or how I justify their place as belonging there, has shifted completely.

Despite their differences in form, my echochambermusic poems all foreground the musicalities of language bound up in my own processes of sense-making, simply by using the various melodies, cadences, and other sonic materials that make up everyday speech. At the time of their creation, I understood each of these poems to be documenting acoustic values produced by the bodily labor of reading text. But in retrospect, I now understand my echochambermusic poems to also be doing something else entirely: using repetition to explore and exploit the overlap

between poetic language and unprocessed trauma.

To magnify this shift in perspective, I want to discuss a specific example. I wrote a sound poem called "Stay" in 2011, just prior to beginning to write the poems that would ultimately comprise *Fetal Position*, a meditation on the labor of emergence that was my first book published with an outside editor, which I wrote over a decade of undergoing intensive therapy to process extensive childhood trauma. "Stay" is a highly repetitive poem that modulates quotidian phrases used to control children and pets ("stay," "stop," "shh," "quiet," "don't move," "drop it," "stop squirming," etc.). The piece is scored for loop pedal, wherein the loop restarts at the break of each stanza. As I perform it, I have to increase the volume of my voice, eventually shouting to stay audible over the noise that builds from the feedback of looping voices accumulating.

At first, I made "Stay" to amplify the inextricable link between musical reasoning and silent reading practices in response to an escalating problem in my life as a graduate student: my ever-slowing ability to respond to others in writing. This terror was exacerbated by the increasing displacement of vocal inflection in rushed text messages and emails— intonational information which I rely on to detect interpersonal conflict. As the cellphone grew to become more and more ubiquitous, I struggled increasingly to interpret the nuance of tone while communicating with friends and colleagues, especially when that writing was intended to substitute for time-sensitive, live conversation. In the years that would follow, I saw that I was not alone in this confusion, as conflict on social

media would similarly escalate in comment threads all over the place as a result of the word divorced from its acoustic information. Years later, I learned that the musical signals and facial expressions of live dialogue that were missing from those texts and emails are vital for navigating safely in a conversation, especially for survivors of trauma who operate at a different baseline of hypervigilance toward threat than so-called neuro-typical people.

Driving me crazy at the time of scoring "Stay" was the consensus in my small corner of the poetry community that "there is no such thing as repetition in poetry, there is only recurrence." In talking with friends and colleagues about "Stay" as I built it, whenever I would refer to the repetition in the piece, they would quickly correct my word choice. "*There is no repetition in poetry to discuss, Gertrude Stein said so,*" my professors and classmates interjected. Their common denial parroted Stein's oversimplification of the concept in her lecture "Portraits and Repetition," where she asks, "[i]s there repetition or is there insistence? [...] I am inclined to believe there is no such thing as repetition," she hypothesizes. Suspicion of the form seems healthy, but all-out denial of repetition's existence doesn't make sense. The point at which I began feeding the poem into my loop pedal was when I began narrowing the poem's aim to the sole purpose of disproving the popular myth that repetition doesn't exist in poetry by deliberately putting repetition into my poems.

The rumored nonexistence of repetition as a general rule that circulated during that period was odd, given how frequently and identically I heard them

repeat to each other Stein's line verbatim as we read together her 925-page book *The Making of Americans: Being a History of a Family's Progress* (*MoA*). According to Tanya Clement's 2008-2012 research, which uses big data to map large-scale patterns of repetition across *MoA*, this book is maybe the most repetitive book in the English language, containing the lowest count of original words among the canonized novels, with only 1% "unique" words ("unique," i.e., counting only first mention of each word but not its subsequent repetitions). In contrast, Herman Melville's *Moby Dick* has roughly 8% unique words, Dickens' *Bleak House* has 7% unique words, and James Joyce's *Finnegans Wake* has 25% unique words.[21] *MoA's* extreme repetitiveness makes the plot so hard to remember that the book is rumored to have never been fully read by anyone, not even Stein scholars.[22] At one point, I even made a poem to test Stein's claim in my book *The Making of the Americans* (TROLL THREAD, 2012) by deleting all repeated words in *MoA* after their first mention. The last four words of that version are "recognizing regretted similar similarly," revealing that even when all trace of repetition is literally removed from her book, the theme of *attention paid to repetition* remains undeniably prevalent in *MoA*.

My colleagues' unwillingness to question the authority of the author's reading of her own writing—her poetic statement—disturbed me, given these deep internal contradictions in her work. Materially speaking, on the one hand, yes, particles are incapable of repeating themselves perfectly across space and time. Granted, no two instances of a word encountered on

a page are exactly identical for a reader, because you never step in the same river twice. But by this logic, that means that repetition in my and Stein's works is non-identical, and therefore, the two cannot be compared or conflated, because they are separate and unrelated. In a compositional sense on the other hand, of course Stein used repetitive techniques to compose the work, and elsewhere in her own writing she affirms the existence of the form when she says, "[i]t is the soothing thing about history that it repeats."

Stein's famous denial of repetition's existence was likely in direct response to her failure to publish a less abridged version of *MoA* after years of trying.[23] Her denial could have also farcically responded to the deluge of negative press that *MoA* received from critics early on, who skimmed the repetitive parts and blamed the book for failing to sustain their attention. The gesture of her denial mimics inattention to repetitive form—skimming, abridging, and ignoring are all ways to deny the validity of its existence. Her denial thus prompts resistance to skimming the repetitive parts, inviting us to instead play "spot the differences" rather than "skim similarities," as we read. However, her negation of the form only applies retroactively, making the statement only a paratextual (not textual) instruction for reading the work. As a result, her insistent denial of repetition isn't a description of the work so much as it is a paratext designed to orient readerly attention through the work and guide its reception in discourse.[24] Acknowledging repetition only thickens the plot of its role in the work.

The multivalent function of repetition in poetry, from its musical properties to its ability to translate

trauma into language and transport voices from the past into the present, has impacted my life too profoundly to ignore. For generations, my family has lived at the mercy of repetition, suffering debilitating intergenerational trauma, PTSD, and other physical and mental illnesses resulting in consistently high ACE scores.[25] Common to these pathologies are repetitive behaviors like fixation, obsession, flashbacks, and self-soothing, as well as compulsions to transfer violence by recreating it. In my family, these pathologies largely developed as a direct consequence of austerity and the lasting scars poverty impressed on us over generations, even enduring over periods in which their impoverishment decreased. The worst part about trauma is the reliving of horrible events repeated in the present long after they have ended.

When I listen to recordings of "Stay," my attention doesn't hover over the differences between words recurring across the text. What I hear in it is a soundscape that is uncannily similar to what my childhood home sounded like—a cacophony of shouting, fear, and insidious aggressions to repeat past violences through the replication of harm. The first time I heard a recording of "Stay," I was struck by a flashback of listening through a wall to screaming as I struggled to discern whether anyone was murdering or being murdered, and whether to call 911. This flashback was the first time I consciously thought about those events since experiencing them as a small child. Poetry for me was never a purposeful instrument or springboard for therapy. But hearing that poem externally for the first time, I couldn't ignore any longer the existence of

something so deeply etched into my bodily memory as repetition's violent legacy carved into the history of my own family's progress.

I'm always reluctant to disclose the details of that side of my life in my professional writing, because I still have a relationship with my family, and because I don't like reducing the sense that a poem can make to a single, ancillary story or detail, whether that be an anecdote from an author bio, a theory that author's work resonates with, or a medical diagnosis. Doing so subordinates the intelligence of the poem to the supremacy of a reductive, anterior logic. I need my poems to do more than what was done to me. But given my limited access to the critical distance needed to objectively observe my own work, I remain more curious to learn what others hear in my poems than impose my idiosyncratic interpretation of them. However, my desire to invite readers to do anything with the repetition besides deny its existence has outgrown my desperation to pass as a good scholar at this point.

There are so many more ways repetition could be talked about in poetry than it is. When I was small and learning to read, whenever I encountered a word that was illegible to me, the first step I took to understand it better was sounding it out syllable by syllable. Today, sounding it out is still my go-to method for making sense of the noise. When trying to remember the forgotten lyrics to a song, I first hum the tune to jog my memory of the words. The tune tends to develop before I'm able to enunciate the words. In both instances, music is a primary measure I use to make sense of language.[26] This acoustic capacity—for a repeatable melody to aid

memory—makes musical repetition essential to the compositional method of poetries in the oral tradition also. Repetition of tones, musical phrases, rhythms, and melodies are primary organizing devices for parceling and transmitting information, from metered epics to the griot's melodious word of news from the countryside. Today, the repetition of a pattern perfectly mirrored by two computers forges a link that enables us to send information to each other (computer engineers and programmers refer to this version of the repetition that parcels information as a "packet").

The abundance of musical forms of repetition in "Stay," such as echoes, rhythms, and recurring melodies, played a profound role in the bodily sense-making of language and memory for me. The poem furnished me the formal means to begin accessing and renegotiating with intrusive narratives echoing from my past. But I can't for the life of me describe what repetition in these poems does for anyone else besides me, not even in a basic sense. This is true of the other poems I store in my echochambermusics folder as well: these poems all use repetition as their primary means to echolocate the enclosures of their complex. But in doing so, each has also transformed my own way of seeing, transporting me to somewhere other than where I started every time as a result. Recalling the tune of my childhood through "Stay" enabled me to begin noticing and revising the stories I told myself about the parts of my past I had not yet reckoned with, especially those parts that most threatened to repeat.

So perhaps the reason why we didn't talk more seriously about repetition in those seminars was be-

cause its overlap with trauma as a topic of discussion usually belongs to a taboo, socially unspeakable category. Until it is fully processed, my therapist tells me, trauma is most commonly expressed through what we are driven to repeat—"we act out what it is that we cannot say" she always says. Indeed, so long as the author is alive, trauma that affects an author and/or their family isn't exactly professional workplace banter for the author or the critic. Thus, explicating the traumas that shape reading practices is less assimilable for literary criticism, because its discourse is mediated by workers in a university during business hours. And I mean, I get it: If literary critics really tried to explicate the feedback loops of their own projections onto what they read in full disclosure and honesty, where would discourse draw the line? Wouldn't the conversation just devolve into an Olympics of suffering—the writer with the saddest personal story winning the contest for attention every time? How would the most privileged among us so easily ascend academia to outrank survivors and working-class peasants if we abandoned the decorum of professionalized poetry discourse in a university setting? But this counterargument to such a possibility—itself a slippery slope argument—seems merely a defense against change. Today, the abusive relationship poetry has with US educational and arts institutions (because of their growing failure to financially support poets) destabilizes foundational notions of aesthetic beauty and poetic value common to our overlapping discourses.

Income inequality in the literary world worsened so severely during the period in which I've written

the echochambermusic poems—with the defunding of public education heavily impacting my field, my department, and poetry discourse at large—such that the common denial of repetition in my community made me question my own compatibility with my education and the poetic medium. I didn't know how to square being a practicing poet who'd lived below the poverty line before and since my doctoral degree with laboring to assimilate into an academic system built to trap working-class kids like me into lifetimes of debt. If critics were to actually account for how their own traumas shaped the way they criticized work, they would have to begin acknowledging poetry's relationship with the university's structural inequalities and exploitative labor practices that heavily undergird the American poetry tradition and its discourse. If critics explicated the traumas organizing their attention paid to poems, many would have to actually reckon with or even challenge the extent to which poverty wages for poets and graduate students, along with poetry's romanticization of poverty, is more problematic in an age when class mobility via education is dead. The injustices of student debt and the adjunctification of the university heavily shape its discourse by disproportionately hindering poor and working-class writers from ascending the ranks of meritocracy and poetic prestige. The collective repression of institutional abuse shaping poetry discourse is why, no matter how hard I tried to pass for a "good" scholar by mirroring the beliefs of the elite in my institution, I could not match my understanding of poetic language with those around me. To deny the

existence of repetition is to ignore its damaging effects on me and my family generation after generation.

If repetition is the medium through which violence passes, and part of the zeitgeist now is one in which violence is rising all around us through rapidly worsening inequality, precarity, and hate, then who does it really serve to keep pretending repetition doesn't exist? The thousand hours of biweekly therapy for a decade that I spent training to resist the monster I was raised to become has convinced me that cycles of violence aren't stopped in silence—repetition only becomes subvertable after its translation into language.

There was a moment recently when all of a sudden my poet friends disclosed the place of their traumas in their poetry, but that moment more or less discontinued when, during the COVID-19 pandemic, trauma came to appear so evidently ubiquitous that it fell back into a state of casual unremarkability. But the unremarkable needn't mean unspeakable. The genius, never-tenured critic Mark Fisher argues that trauma is far from unique in a capitalist society that runs on ubiquitously exploited labor. To him, "[t]here is no such thing as an autonomous individual."[27] "In order to really come to terms with the damage that has been done to them by and in the wider social field," Fisher writes, "individuals need to engage in collective practices that will reverse neoliberalism's privatisation of stress."[28] Out of all of that precarity that he struggled through as an adjunct, Fisher arrived at the conclusion that essentially, "the pandemic of mental anguish that afflicts our time cannot be properly understood, or healed, if viewed as a private problem suffered by

damaged individuals."[29] And I'm inclined to agree that the belief that trauma and its treatment is merely a personal struggle and not also an utterly political matter perpetuates neoliberalism's "privatization of stress." His question is thus generative for getting around those old neoliberal trappings: "When can talking about our feelings become a political act? When it is part of a practice of consciousness-raising that makes visible the impersonal and intersubjective structures that ideology normally obscures from us."[30] To him and me, trauma's ubiquity makes it no less valuable a topic of discussion for these reasons. The incompatibility of Stein's denial of repetition with different notions of repetition traveling through music and trauma studies could be a starting point for widening our means of including marginalized forms of knowledge (such as aurality and affliction) in literary discourse.

It's difficult, however, to describe ubiquitous things in expository writing because to describe something ubiquitous—like austerity, which is everywhere—requires one to make hasty generalizations. Luckily, though, because poets aren't bound to the same logical rules as expository writers, we can more easily render into language unfathomably ubiquitous things like love and war and death. In the years since making "Stay," I've thus grown increasingly obsessed with using poetry to study ways that musical repetition functions as a mechanism of seemingly unremarkable reading practices. As a material, repetition can be used to parcel information, collapse spatio-temporal boundaries, as well as transport expired voices into the present. Because my interest in poetry has never

been focused on mastering intelligible and knowable concepts, but rather in rendering detectable the categorically unremarkable, unspeakable, and unsayable, I'm curious to learn more about the formal means by which repetition can be used to summon suppressed and repressed knowledges.

But evident in my shifting account of my own poetics and Stein's shifting understanding of her repetition is proof that living in a permanent state of becoming makes poets unreliable narrators of their poetry. Repeating the same old story to explain a continuously changing world does not substitute for paying time and attention to work that defies the stories we inherit. The stories we tell ourselves to understand the poems we read are plastic and can be playfully, even limitlessly manipulated.

Both while writing and while reading, a whole universe of potential play is bound up in the irreducible difference between text and paratext. So I want to keep working through ways that writing can be arranged to interact with and even change these voices from the past echoing in the present. If repetition, musical and otherwise, is a medium through which violence can be reenacted and thus transferred, then I think its formal facility in writing deserves more exploration and less denial. Reliving an event such that a repetition is experienced can terrorize, ironize, or corrode, but it can also reshape meaning.

NOTES

1 Sophie Seita, "Thinking the Unprintable in Contemporary Post-Digital Publishing," *Chicago Review* 60, no. 4 (Fall 2017): 175–94.

2 Some might include Ad Reinhardt's 60×60-inch black oil on canvas called "Abstract Painting" (1963), Kazimir Malevich's 80×80-inch black oil on linen called "Black Square on White Ground" (1915), maybe even Goya's nineteenth-century "Pinturas Negras," and more. Some print works might include anything from government-censored documents to Marcel Broodthaers' black-out edition of Mallarmé's "Un Coup de Dés" (1969) to the Black Page exhibition (2009), wherein 73 artists/writers created black pages for the 250th anniversary of Laurence Sterne's all-black page 73 of *Tristram Shandy*. And then there's the larger tradition of "mourning pages" (all-black pages that commemorate the dead) appearing in pre–twentieth-century printing press tradition—and of course there are many more (in this way, Yedda Morrison's *Darkness*, a linguistic excision of Conrad's *Heart of Darkness* by way of "whiting out" black ink in the text, which could also be noted here as among the company in the above). The list goes on.

3 Similar in some ways to the work at hand, Mishkah Henner's *Astronomical* is also a PoD book of all-black pages, except his is a 12-volume, 5.5×8.5-inch set that did effectively print via a different company (October 2011). According to his statement, the accumulative width of the book totals 6,000 pages, reflecting the distance from the Sun to Pluto at a scale of one page per 1,000,000 kilometers. Potentially even uncanny in resemblance is Jean Keller's *The Black Book* (April 2011). According to his readers, this work is also a PoD book of 740 all-black pages, and is similarly for sale on

Lulu. About this 5.83×8.26-inch book retailing for $32.02, the author's statement notes that a single gallon of digital printing ink costs $4,000, whereas, "[a] book containing the maximum number of pages printed entirely in black ink therefore results in the lowest cost and maximum value for the artist. Combining these two features, buyers of *The Black Book* can do so with the guarantee that they are getting the best possible value for their money." The book presents the consumer with an account of fiscal effects. However, according to the identical automated "file error" and "order refund" emails that Lulu sent me when I tried to purchase Keller's *The Black Book*, one could argue that his is not the book that has so far been described. Does *The Black Book* really maximize the consumption of ink? Did it do so at one time or does it still? How much does the duration of the work depend upon the durability of the printer? If not a print-on-demand book via Lulu, then doesn't Keller's book exist in concept alone?

4 Holly Melgard, *Black Friday* (Madison: Oxeye Press, 2014).

5 Brian Reed and Craig Dworkin, "Untitled Conversation," in *Affect and Audience in the Digital Age*, ed. Amaranth Borsuk (Athens: Essay Press, 2014), 1-16.

6 CAConrad, "CAConrad Interviews TROLL THREAD," *Facebook*, May 15, 2012. https://www.facebook.com/CAConrad88/videos/10151707996715307. At 14:04 in the video, Joey Yearous-Algozin exclaims, "I write poems with a computer that cannot be unplugged largely from the internet that I steal and I put these poems up on the web for anyone to take—This is what actual poor publishing looks like!"

7 Juliana Spahr and Stephanie Young. "Numbers Trou-

ble," *Chicago Review* 53, no. 2/3 (Autumn 2007): 88–111.

8 Spahr and Young, "Numbers Trouble," 96.

9 Matvei Yankelevich, "'Power to the People's Mimeo Machines' or the Politicization of Small Press Aesthetics," *Harriet Blog*, Poetry Foundation, February 3, 2020. https://www.poetryfoundation.org/harriet-books/2020/02/power-to-the-peoples-mimeo-machines-or-the-politicization-of-small-press-aesthetics.

10 Danny Snelson, "*Heath*, prelude to tracing the actor as network," 2010. http://aphasic-letters.com/heath/. Eventual TT author Danny Snelson began tracing ways that Lin "plays" with paratext in an early self-published essay, where he notes that *Heath* "[e]mphasizes the *softness* of the paratextual threshold."

11 That year, another eventual TT author, Kristen Gallagher, also commented on the "performative" nature of *Heath*'s design in "The Authorship of Heath Ledger in the New Reading Environment on Tan Lin's *Heath*," *Criticism* 51, no. 4 (2010): 701-9. The conversation began to grow formally through the making and exchange of our own works from there.

12 Gérard Genette, *Paratexts: Thresholds of Interpretation*, trans. Jane E. Lewin (Cambridge: Cambridge University Press, 1997), 1.

13 Its "Terms of Service" state that "[u]sers are expected to conduct proper research to ensure that the Content sold through the Site is in compliance with all local, state, national, and international laws. If Lulu determines that the Content is prohibited, we may summarily remove or alter it without

returning any revenue from sales of the prohibited Content. Lulu reserves the right to make judgments about whether or not Content is appropriate."

14 Titles include *The Plandemic* (Version 6): *Corona Virus Vaccine is Genocide* by Adrian Bonnington, *COVID World Order: Resetting Humanity 2.0 and Medical Martial Law* by Luis Vega, and *The Great COVID Deception* by Billy Crone.

15 Jonathan Freidman and Nadine Farid Johnson, "Banned in the USA: Rising School Book Bans Threaten Free Expression and Students' First Amendment Rights (April 2022)," PEN America, April 7, 2022, https://pen.org/banned-in-the-usa/.

16 For more on class struggle within an economy of twenty-first–century American poetry publication, see Josef Kaplan's "Poem That Is Pro-Violence" in the concluding chapter of his *Democracy Is Not for the People*. (Josef Kaplan, *Democracy Is Not for the People* [Sunnyside, NY: Truck Books, 2012].)

17 For more oedipalizations of Lyn Hejinian's "Rejection of Closure," see Joey Yearous-Algozin's "The Radically Closed Text" (Buffalo, NY: Becoming Poetics, 2010).

18 This was originally a question that Trisha Low asked me in 2010, out of which much discussion transpired between her, Divya Victor, and me in the years that followed. Still, we all fall on different sides of this debate. There are overlaps between our ideas, but this is my take. For more about this debate, see the concluding chapter to *Purge* (Trisha Low, *The Compleat Purge*, [Chicago: Kenning Editions, 2013].)

19 The essential definition of feminine form that the deconstructionists theorized only makes sense to me in

abstraction. Their theories articulated the feminine as an extreme position in relation to the masculine. In purely abstract terms, the feminine is absolutely passive matter that has no agency, and is only constituted as an object of desire in pursuit, never as a subject that can pursue. Luce Irigaray even went so far as to say that the feminine is a figure so imminently passive that it is spatially ambient, such that it can never be fully regarded because it continuously recedes over the horizon of intelligibility. By this definition, the feminine is a figure that lives in a state that is utterly unfit for human consumption.

20 After listening but failing to hear/note silence in the anechoic chamber, John Cage concluded that "there is no such thing as silence." As Giorgio Agamben asked in his 1978 book *Infancy and History*, "how much can silence be heard prior to translating it into sound?" Cage likely couldn't account for silence because he was measuring it only through the rubric of sound.

21 Tanya Clement, "The Makings of Digital Modernism: Rereading Gertrude Stein's *The Making of Americans* and Poetry by Elsa von Freytag-Loringhoven" (PhD diss., University of Maryland, 2009), 27.

22 Dick Higgins, "Why Gertrude Stein," in *Gertrude Stein Advanced: An Anthology of Criticism*, ed. Richard Kostelanetz (Jefferson: McFarland & Company, 1990), 51–54. In the first half of the twentieth century, *MoA* was met with many critical responses that considered *MoA* to be so "unreadable" that interest in publishing an unabridged edition of the book didn't transpire in discourse until the mid-1960s. After Something Else Press released the unabridged edition in 1966, its editor, Dick Higgins, remarked that "*[T]he Making* is a 'great novel,' which, ostensibly, nobody can read" (51).

23 Lawrence S. Rainey, "Book Review: *The Making of Americans*," *Modernism/Modernity* 4, no. 2 (1997): 222–24, https://doi.org/10.1353/mod.1997.0025. As Rainey's historicization of *MoA*'s reception points out, despite having completed the manuscript by 1911, Stein only managed to release excerpts of the book through abridged editions in small print runs in her lifetime. Lectures in America, where "Portraits in America" was published, came out one year after the first full-length but abridged edition of *MoA* (only 286 pages in length, less than a third of the original manuscript) was published in 1934 by the American firm Harcourt Brace with a print run of more than 100 copies and distribution in the US. The first fuller-length, 925-page edition wouldn't be published by Something Else Press until 1966, two decades after her death.

24 As discussed in "PoD Self-Publishing After the Rise of Misinformation Got Us Killed," paratexts are things like blurbs, synopses, book covers, and even separate author bios and interviews, all of which are peripheral dimensions of text that designate boundaries for its reception in discourse, as Gérard Genette theorizes in *Paratexts: Thresholds of Interpretation*. They "are those liminal devices and conventions, both within and outside the book, that form part of the complex mediation between book, author, publisher and reader: titles, forewords, epigraphs and publishers' jacket copy are part of the book's private and public history," he writes. The repetitive surface dimensions of a book's paratexts are what make its contents appear usable, navigable, and knowable, thus framing the book-object as a book (spine, page numbers, font, publication page, title, author, etc.). Even though writers and publishers spend exorbitant time and money composing paratexts to guide readers to and through their work, standards in mainstream publishing strategically mask paratextual labor to appear invisible and

unobtrusive to readers. In other words, paratexts are reading tools that authors and their publishers can have a hand in shaping, manipulating, and transforming for readers. Not all of the tools used to read text come from paratexts, and not all paratextual instruments are consciously adopted or willfully chosen.

25 The ACE Score refers to a metric recommended by the Centers for Disease Control and Prevention that doctors and psychologists are increasingly using to measure the magnitude of a person's early exposure to adverse childhood experiences (such as witnessing or undergoing physical, mental, and sexual abuse; chemical dependency; mental illness; neglect; etc.). Most everyone scores at least one on this test, but statistics show that high ACE scores correlate to higher rates later in life of extreme mental and physical illness, including heart disease, diabetes, depression, anxiety, and chemical dependency. High ACE scores, which are a useful predictor of illness to warrant proactive treatment, are more common in working-class and impoverished communities with households destabilized by austerity.

26 Recalling forgotten words in the lyrics of a song by way of humming a tune is something Henri Bergson discusses in *Matter and Memory*, where he writes, "I may be able to catch a tune to follow its phrasing, even to fix it in memory, without being able to sing it" (138). "The true effect of repetition," he writes, "is to decompose and then recompose, and thus appeal to the intelligence of the body." This is a very different idea of repetition than Stein's denialist stance that is typically cited by her scholars, but Bergson is someone she was definitely reading and overlapping with in Paris during the years that she wrote *MoA*.

27 Mark Fisher, "Anti-Therapy," in *K-Punk: The Collected*

Unpublished Writings of Mark Fisher, ed. Darren Ambrose (London, UK: Repeater Books, 2018), 597.

28 Fisher, "Anti-Therapy," 598.

29 Simon Reynolds. "Mark Fisher's K-Punk Blogs Were Required Reading for a Generation." *The Guardian*, January 18, 2017, https://www.theguardian.com/commentisfree/2017/jan/18/mark-fisher-k-punk-blogs-did-48-politics.

30 Fisher, "Anti-Therapy," 598.

ACKNOWLEDGMENTS

"Introduction" is the written score for a sound poem using the instrumentation of a microphone and eight voice recorders, which was originally performed at Soundlab in Buffalo, NY, in February 2009 as part of the "Planned Obsolescence: Reading and Media" event curated by Justin Parks. The event featured work that was geared toward addressing "notions of ephemerality through imaginative uses of obsolete technology, or technology that will soon be obsolete."

"Narsolicitation," the score for a sound poem using the instrumentation of a loop pedal, was first performed at the Crane branch of the Buffalo Public Library as part of the "Wordflight Reading Series" curated by ryki zuckerman in March 2010.

"Stay," the score for a sound poem using the instrumentation of a loop pedal, was first performed in 2011 at the Kelly Writers House for the Emergency Reading Series curated by Julia Bloch and Sarah Dowling. A recording of "Stay" was featured online in the Volume 16: Hypnopoeia issue of *Drunken Boat* curated by KPrevallet in 2012. A remastered version of "Stay" was featured on Textsound issue 21, curated by Michael Nardone, in 2016. https://textsound.org/index.php?VOL=1&ISSUE=21&TRACK=08nbspStay.mp3. From January 16–June 26, 2017, it also played on a loop in the storefront of Los Angeles Museum of Contemporary Art as part of the "This Known World: Spontaneous Particulars of the Poetic Research Bu-

reau" show curated by MOCA Senior Curator Bennett Simpson and Poetic Research Bureau founders Andrew Maxwell and Joseph Mosconi with Executive Assistant to the Chief Curator Hana Cohn.

Colors for Baby, *Foods for Baby*, and *Shapes for Baby* comprise parts I, II, and III of the *Poems for Baby Trilogy* published by TROLL THREAD press in 2011.

The Making of Americans was first published by TROLL THREAD press in 2012. Excerpts from *The Making of Americans* were first published in *Elective Affinities: Cooperative Anthology of Contemporary U.S. Poetry*, edited by Carlos Soto-Román under the title "First, Middle, and Last 100 words in *The Making of Americans* Sans Repetition" in 2012. http://electiveaffinitiesusa.blogspot.com/2012/11/holly-melgard.html

Black Friday was first published by TROLL THREAD press in 2012. "Statement on *Black Friday's* Poetics" and "How to Make *Black Friday*" were first published in *Revista Laboratorio Dossier of Conceptual Writing*, edited and translated into Spanish by Carlos Soto-Román in 2013.

Money by Maker was first published by TROLL THREAD press in 2012.

Reimbur$ement was first published by TROLL THREAD press in 2013.

All of Holly Melgard's books published on TROLL THREAD can be accessed for both free download and print-on-demand purchase through TROLL THREAD's Catalogue page. https://trollthread.tumblr.com/CATALOGUE

All commentary on and photographs of Melgard's work provided by Annette Gilbert and Andreas Bülhoff were originally published on the Library of Artistic Print on Demand: Collection and Research, an online, international archive that they cofounded and edited from 2019–2022 (a collaboration of Free University of Berlin, University of Erlangen-Nuremberg and the Bavarian State Library, which is funded by the German Research Foundation). www.apod.li

The chapbook *Catcall* was first published by Ugly Duckling Presse in 2017.

"Alienated Labor" was first published in Wesleyan's 2015 *Best American Experimental Poetry Anthology*.

A version of "Reproductive Labor" was edited for silent reading and published in the Fall 2021 issue of *BOMB Magazine* (Issue 157). See *Fetal Position* (New York: Roof Books, 2021) for the unabridged performance version of this text.

The excerpt from *Inner Critic: A Journal of Inner Criticism* was first published in *Convolutions* vol. 4 in 2016.

"PoD Self-Publishing After the Rise of Misinformation Got Us Killed" was first published in *Post-Digital Publishing in Times of Platform Capitalism*, an anthology edited by Andreas Bülhoff and Annette Gilbert of the Library of Artistic Print on Demand and published by Spector Books out of Leipzig, Germany, in 2023.

The interview "Their Anger Was Encouraging: Holly Melgard on the Poetics and Politics of Mothering" was conducted by Aaron Winslow and first published in November 2020 as part of the Conversations series for *Air/Light Magazine*. https://airlightmagazine.org/etc/conversations/melgard. The poem "Divisions of Labor" discussed in this interview was published by Make Now press in 2020 and reprinted in *Fetal Position* (Roof Books, 2021).

A version of the excerpt from "Holly Melgard Reads Holly Melgard: A Self-Interview" was published as part of the *Essays for a Canceled Anthology* series by TROLL THREAD press in 2017.

A version of "Echochambermusics: Notes Toward a Trauma-Informed Poetry Pedagogy" was delivered in the form of a talk at Harvard University's Mahindra Humanities Center for the Sound as Knowledge Roundtable curated by Sophie Seita and Alex Rehding (November 2019).

Infinite thanks to every friend, colleague, curator, editor, teacher, student, and mentor whose humbling

encouragement enabled the materialization of works included in this volume, including Chris Alexander, Hannes Bajohr, Derek Beaulieu, Marie Buck, Andreas Bülhoff, CAConrad, Jordan Dunn, Patrick Durgin, Craig Dworkin, Jackie Ess, Rob Fitterman, Lewis Freedman, Kristen Gallagher, Annette Gilbert, Judith Goldman, Rainer Diana Hamilton, Liz Howard, Lucy Ives, Josef Kaplan, Myung Mi Kim, Shiv Kotecha, Tan Lin, Trisha Low, Ming-Qian Ma, Andrew Maxwell, Steve McCaffery, Annie Melgard, Callan Melgard, Amanda Montei, Joseph Mosconi, Allison Parrish, Alexandra Petrou, KPrevallet, Kim Rosenfield, Jocelyn Saidenberg, Benjamin Samuel, Leonard Schwartz, Sophie Seita, James Sherry, Ara Shirinyan, Allison Siehnel, Carlos Soto-Román, Paul Stephens, AJ Strosahl, Chris Sylvester, Bridget Talone, Dennis Tedlock, Deborah Thomas, Orchid Tierney, Macy Todd, Mónica de la Torre, Divya Victor, Aaron Winslow, Virginia Wyland, Matvei Yankelevich, Stephanie Young, and Steve Zultanski. Extra thanks are owed to my muse, Crayon Melgard. The most thanks belong to Daniel Owen, the editor of this volume, whose generous vision, collaboration, and patience made this book possible. This book is dedicated to my coconspirator and relentless instigator Joey Yearous-Algozin, whose influence is all over this book and who is banned from ever dying.